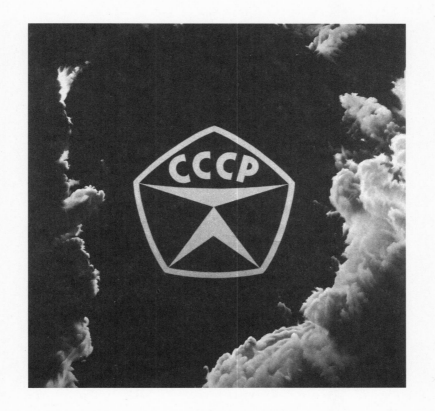

TRADE MARK, 1986 200×200 cm / 79×79"

ERIK BULATOV
MOSCOW

Institute of Contemporary Arts, London
February 22 — April 23 1989

MIT List Visual Arts Center, Boston
May 6 — July 2 1989

The Newport Harbor Art Museum, Newport Beach, California
July 27 — October 1 1989

The Renaissance Society at the University of Chicago
October 8 — November 25 1989

Parkett Publishers in collaboration with ICA London

ACKNOWLEDGEMENTS

This first exhibition of Erik Bulatov's work in Great Britain and the United States has been greatly facilitated by many people. First and foremost we would like to thank Erik Bulatov for his warm co-operation, and Claudia Jolles, who initiated the first major exhibition of Bulatov's work at the Kunsthalle in Zurich in 1988 and who has assisted in every aspect of its continuation to Britain and the United States.

The ICA would also like to thank for their assistance Mr. Fedosov, Cultural Attaché at the Soviet Embassy in London; Mr. T. Salachow, Secretary of the Artists' Union in Moscow; Stephen McEnally, Cultural Attaché at the British Embassy in Moscow; Galina Main, Darmstadt; Stanislas Zadora, Paris; and Claus Henning, Director of Visiting Arts in London.

The owners of Erik Bulatov's work have responded with great generosity to this exhibition, and their enthusiasm has enabled the fullest possible representation of this artist. Our sincere thanks to Carey Cameron, Rome/Washington; Igor Chelkovski, Paris; Norton Dodge, Maryland; Karl and Bianchi Fritschi, Geneva; Phyllis Kind, New York; Livet/Reichard, New York; Paul and Erna Jolles, Bern; Philippe de Suremain, Paris; Dina Vierny, Paris; and Irene Wydler, Zurich.

Iwona Blazwick, James Lingwood, ICA.

FOREWORD

For over twenty years, Erik Bulatov has been living and working in Moscow, making a picture of his world. This is an endeavour which the artist is compelled to describe in ethical terms: "Our task, and the task of our generation, is to show that this world depicted as unshakeable, immovable and eternal is not everything. On the contrary, something also exists on the other side of the boundary. And this world is, in fact, false, ephemeral and untrue." Bulatov shares this language of responsibility with his artistic colleagues in Moscow, most notably Oleg Vassiliev and Ilya Kabakov and it distinguishes them as opponents of opportunism and of political and aesthetic posturing.

Bulatov's work has been predicated on an exploration of light and space, and a sceptical investigation of reality – not only of a specifically Soviet reality, but of the concept of reality itself. Such a version of social realism – with its images of uncertainty rather than stability, its interrogation of the power of language and its limits will, we hope, resonate in Western cultures where many contemporary artists engage in similar investigations. This first full-scale exhibition of Bulatov's work in Britain and the United States provides also the opportunity to assess the aesthetic and ideological purposes for which Bulatov manipulates familiar sights, situations and iconographies.

In the present climate of perestroika, it appears that the immovable has begun to move, the absolute is becoming relative. Such a change offers a profound challenge to an artist whose work explores the tensions between ideology and existence, enclosure and escape; who interrogates the distance between official language and unofficial life, and the dissonance between the image of an idealised, universal world and the picture of an existence within it.

In an as yet unfinished work (Bulatov often takes several years before the picture is complete), the space of the horizon and sky is threatened by ominous, foreboding clouds. But the direction of the movement is unclear. Will the viewer be engulfed, or will the space be cleared? History may provide an answer. But it should not reduce the necessary ambiguity of Bulatov's ethical project.

Iwona Blazwick, James Lingwood, ICA London
Katy Kline, MIT List Visual Arts Center
Paul Schimmel, The Newport Harbor Art Museum
Susanne Ghez, The Renaissance Society at the University of Chicago

This publication coincides with the exhibition Erik Bulatov at the ICA London from 23.2.–23.4.1989.

Exhibition conception: Claudia Jolles
Editor: James Lingwood
Translations: Material Word, Catherine Schelbert, Martin Scutt
Design: Trix Wetter
Photographs: Igor Chelkovski, Michael von Graffenried, Juri Schettow, Dominique Udry
Colour separation: Litho AG, Aarau
Typesetting and Printing: Zürichsee Druckerei Stäfa

Parkett Publishers in collaboration with ICA London

© Parkett Publishers (Zurich – Frankfurt – New York)
© ICA London
Printed in Switzerland 1989

ISBN. (Parkett Publishers) 3–9075–0903–X
ISBN. (ICA) 0 90 5263 42 1 for Great Britain, Canada, Japan, Australia
US distribution: Untitled II Inc., 680 Broadway, New York, NY 10012

Parkett Publishers, Quellenstrasse 27, CH-8005 Zürich, Tel. 01-271 81 40
ICA, The Mall, London SW1Y 5AH

The Institute of Contemporary Arts is an independent educational charity and while gratefully acknowledging the financial assistance of the Arts Council of Great Britain, Westminster City Council, the London Borough Grants Unit and the British Film Institute, is primarily reliant on its box-office income, membership and donations.

Exhibitions Director: Iwona Blazwick
Curator: James Lingwood
Gallery Manager: Stephen White
Exhibitions Administrator: Ingrid Swenson
Publications Officer/Archivist: Gail Reitano

Presented in London with the assistance of Visiting Arts.

MIT List Visual Arts Centre, Boston, Massachusetts
Curator and Acting Director: Katy Kline
Presented in Boston with the support of the Art Exchange Program of the Massachusetts Council on the Arts and Humanities.

The Newport Harbor Art Museum, Newport Beach, California
Chief Curator: Paul Schimmel
The Museum is supported in part by grants from the National Endowment for the Arts, a Federal Agency; the California Arts Council, a State agency; the County of Orange; and the City of Newport Beach.

The Renaissance Society at the University of Chicago
Director: Susanne Ghez
The Renaissance Society is supported in part by the Illinois Arts Council, a State agency, and by its membership. Indirect support from the Institute of Museum Services, a Federal agency offering general operating support to the nation's museums.

CONTENTS

ERIK BULATOV
VISIONS OF POWER, THE POWER OF VISION

Claudia Jolles

 Various forms of expression and levels of reality seem to clash violently within Erik Bulatov's works and to co-exist there in conflict. Giant-sized written characters are superimposed upon realistic images and, in so doing, reflect a sense of life which corresponds to an existence that steers a meandering course between a materialistic everyday reality and an individualistic aspiration to spirituality.

The juxtaposition of text and image is a recurrent feature in today's Soviet Union; but instead of having the text pin the visual representation down to a single interpretation, Bulatov allows it to accentuate the picture's ambiguities. His works are never one-dimensional, didactic, sociological pieces. Gogol's formulation, in a letter to Zhukovsky in 1848, is also pertinent for Bulatov – "...I am not interested in teaching like a preacher. Art is, in any case, educative in itself. I am interested in speaking in living images, not in passing judgements".

The social responsibility of the artist has always been a particularly pronounced characteristic of Soviet art. For example, in the 1920s alongside his work on the plans for his adventurous one-man gliders – the "Letatlins" – Tatlin also produced designs for the workers' ideal clothing or for a particularly rational stove. El Lissitsky, Punin, Melnikov, the Vesnin brothers and others all engaged in comparable activities. Suprematism was not only a form of artistic expression, but also affirmed itself as a dominant decorative style in the street life of the Soviet towns of the time. Bulatov is similarly concerned with this connection with everyday forms of expression which are widely accessible.

In using the language of official proclamations on posters and propaganda banners, Bulatov endeavours to establish contact with the reality that surrounds him and to assume and assert a particular artistic position. The claim to this individual position is also the reason why, until Perestroika, Bulatov

was denied official recognition and was obliged to work as an illustrator of, amongs other things, botanical books.

Unlike his colleague and great friend of many years' standing, Ilya Kabakov[1], Erik Bulatov is no ingenious inventor so far as his means of expression is concerned. He stands firmly within a specific artistic tradition, one that pays great attention to painterly quality and manual skills. These never become ends in themselves however, nor demonstrations of virtuosity, but are subordinated to a particular content. To pluralist arbitrariness, Bulatov counterposes the one and only artistic language of his environment, socialist realism, but instead of submitting to its strict representational conventions, he enlists the style into the service of his own vision.

Bulatov has not, like Komar and Melamid, found refuge in irony but has sought, through his paintings, to elucidate the diffuse structures of power which determine his life. In this process, open space becomes the three-dimensional illusory space of a picture, dominated by the watchwords and slogans that are placed within it.

In his realistic images, Bulatov is not seeking photographic fidelity, but the creation of a particular sense of space which functions not as a static, clearly measurable factor but rather as something dynamic, accessible to personal experience. In his work, space only becomes plausible as a result of the light that crosses it. The surface of the painting seems not actually to reflect light, but to generate it or to transmit it to the viewer from some source located behind the canvas and thereby becoming a kind of connecting spatial passageway. The significance of light is crucial for Bulatov. Objects, by contrast, are merely pretexts which serve to pass on the reflection of the light. «I always paint light, and what emerges from it is the object».[2]

Clouds, snow and sea are elements which suggest light, depth and movement. Light stirs the painting into life, enables it to create its illusion of depth, which Bulatov interprets as spiritual freedom of movement, and to which he thereby accords existential significance.

Bulatov developed his style without reference to American photorealism. Instead of using slide projections which are copied directly onto canvas, he works from photos, postcards or magazine illustrations, copying them freehand or adding detail. He produces meticulous nature studies of plants or human figures in which he analyses the refraction of light on a variety of

surfaces. These enable him later to use as models for his paintings even low-definition newspaper photographs to which he then adds colour.

Bulatov begins his compositions by covering his canvas with a dense layer of cross-hatching with coloured pencil. This preparation ensures the subsequent wide range of tonal shadings. He is a very meticulous painter who completes no more than two or three works in a year, and even these have often been reworked over a period of several years.

Comparisons have often been drawn between Bulatov's work and Pop Art. This is only partly justified, for Bulatov's primary focus is not the object he depicts, but rather the light, the energy behind the reality he portrays. He is not attempting to capture an incidental vision or an objective representation of the reality around him, but is concerned, rather, with metaphorical images that clearly express a distinctive contemporary feeling and a philosophical viewpoint. It is absurd to look for "Americanisms" in Bulatov's work, because what appears "American" in style is the unusual scale of his work (particularly in a country where paint, canvas and available studio space have often been at a premium). But it is precisely this effect that cannot be transmitted by small format magazine illustrations, which were until recently nearly the only source of information available to Soviet artists about contemporary trends in Western art. In Bulatov's work, the visible world is little more than a momentary disturbance in the light radiating from the picture. In this respect he has more in common with traditional Russian icon painting and with Malevich than he has with his American contemporaries of the 1960s. For Malevich, the white background on which he suspends his black square represents nothingness; for the icon painters, the white or golden background embodied the heavenly light. For Bulatov the light signifies neither a divine ideal nor a utopian world view, but rather transfuses a very specific reality. This reality, however, does not give the impression of being absolute or solid; in fact it seems quite fragile, little more than a fiction, and in a recent picture the text warns us "Not to be leaned on».

Malevich's "Black Square" was a recurrent theme in discussions among Bulatov's contemporaries during his student days, although they were not able to see the work in reality until much later. It was then that he realised to his astonishment that the square was not a square at all, and he concluded that it was no portrait of a geometric form, but a representation of a hovering

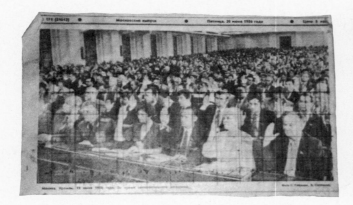

stereometric figure. It was in Malevich's work that Bulatov first encountered a kind of painting that dissolved spatial illusion, that no longer functioned as a surface for projections of the mind. Only the visible world and the material needs of human beings retain their reality. Here the utopia of the 1920s avant-garde has become the nightmare of the avant-garde of the 1960s.

Bulatov repeatedly uses the same motifs, and often paints them in a fashion boldly reminiscent of postcards or of the illustrations in travel brochures – images that often exert a greater influence on our vision of reality than reality itself. Certainly the symbols used would be generally recognisable, and the implications of a painting such as the recently completed "Dispersing Clouds" (1985–86) is self-evident in the current political context. The elements of the picture are always arranged with a view to their relevance to Soviet life, and they represent themes that have traditionally played a leading role in Russian art. The horizon is the boundary of the visible world. It marks the transition between real, tangible existence and the visionary realm beyond. The painting "Horizon" (1971–72) follows on from Bulatov's paintings of the late 1960s, in which he analysed questions of space and surface. In these radically simplified paintings he uses diagonal, horizontal or vertical beams cutting across black or white backgrounds and pointing towards apparently limitless depths. "Horizon" is his first attempt to connect his abstract researches with the aesthetic of his socialist environment. In doing so he distances himself from the historical avant-garde, concerning

11

himself rather with his obligations to the present. In this painting the horizontal cleft has become the actual horizon of a seascape, though this is covered over with a red-gold band. The original inspiration for the group of people here seen making their way happily towards the beach, apparently unaware that the horizon no longer exists, was provided by a postcard.

The landscape, although apparently representing an ideal human environment, is barely ever depicted in its natural state. In paintings such as "Danger" (1971–73) or "Beware" (1973), Bulatov takes warning signs from railways or road signs, separates them from their context as indicators of a specific danger in a particular place and gives them a general relevance. These are the earliest examples in which text is super-imposed on realistic representations.

In "People in a Landscape", the courting couple's picnic loses the trappings of a pastoral idyll, and takes place instead on the bare floor of a room apparently suspended in the landscape. The floor is brown, the walls are painted a griny green – colours of a sort often encountered in Russian tenements – and above all this stretches an open, white ceiling. Is this an attempt to transpose precarious domestic circumstances into natural surroundings? Is it a way of showing people's desperate attempts to bring a little of the romance of field and forest into their own four walls by means of appropriate colours, or is it an interpretation of the natural space as clearly delineated and closed off? Whatever the case, it is impossible to rid oneself of the sensation of being enclosed, isolated.

"Brezhnev in the Crimea" was allegedly intended purely as a landscape painting; but then the politician has invaded the picture plane and has pushed himself in front of the idealised background. Despite the impressive figure cut by the Chairman of the Supreme Soviet, whose pose is modelled on a well-known portrait of Stalin, Brezhnev appears as disembodied as the idealised landscape, which was apparently modelled on a postcard of the shores of Lake Geneva. Politics forms a part of the visible, material world, and here it is generally problematised as an obscuring of the light that emanates from the picture. The portrait of Brezhnev, "Soviet Cosmos", was painted a few years previously (1977). By filling up two thirds of the picture with a ring of flags representing the Soviet republics and leaving only one third to be occupied by the statesman himself, the painter has emphasised the decisive quality of emblems to which the man must submit himself. Even

in the age of perestroika this does not appear to have changed a great deal. On the backdrop to the podium at last year's jubilee celebrations marking the anniversary of the October Revolution, an idealised architectural vista is displayed. A picture of Lenin dominates the centre of this view, framed by the inscription "Revolution-Perestroika, the revolution continues", Gorbachov, the main speaker, intrudes very little upon the picture, although he manages to obscure part of the visible portion of the slogan in such a way that the second word, intended as a noun, becomes the imperative "perestroi" (restructure).

In "Natasha", a blinding white snow scene once again constitutes the main feature of the painting. In the background are a Lenin House, a snow covered monument and a decaying plaque that bears the fading inscription "The name and deeds of V. I. Lenin shall live for ever". In the foreground stands the tourist Natasha, wife of the artist. For a brief moment a spark of life seems to be asserting itself against the flickering light of the background.

Snow is seen by Bulatov as an embodiment of light and whiteness, and always signifies a transitional zone. In "Skier" (1971—74), snow is used as a boundary between two levels of reality: the space occupied by the observer, from which the skier seems to be escaping, and the empty white background whose light almost melts into the snow covered woodland scene. The red railings, which seem to present no obstacle to the determined cross country skier, effectively prevent us from following him into the winter landscape.

Instead of being able to lose ourselves in the endless depth of snow, sea or sky of Bulatov's painting, we are confronted by a network of lines or a latticework of letters, which serve to remind us with brutal clarity that all this is only window-dressing and illusion. The reality is nothing but a surface without depth, a canvas clearly subordinated to considerations of line and typography.

Where Bulatov uses texts, they are always short and clear. A slogan such as "Glory to the CPSU", erected as a one-dimensional grid of letters in front of a cloudy sky, negates any illusion of depth. In "Trademark" (1986) the golden Soviet seal of approval is stamped on the sky and arrests all movement in the picture. Only in the clouds at the corners of the picture is there any sign of light or motion. Last February, in one of the first exhibitions ever to show both official and unofficial artists on the same walls, this painting went on

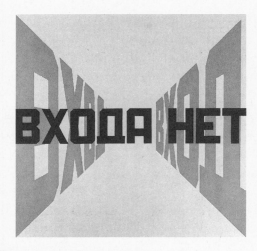

ENTRANCE – NO ENTRANCE, 1974–75 180×180 cm / 71×71″

display in the Kashirskaya Metro, where it attracted a good deal of comment from both the Western and Eastern press.

"Unanimous" (Russian: "odinoglasno") is etymologically related to the concept of Glasnost, the latter being generally translated as plurality of opinion and transparency. Bulatov used a newspaper cutting as a model for this depiction of a vote by the Central Committee. Three preliminary sketches were sufficient to establish the direction of the rows of seats and to overlay the heads with one, then two, and finally three lines of characters. The letters break up the human figures into individual fragments of bodies and skulls, pieces of clothing, meaningless rows of decorations, so turning them into easily manipulable objects.

Something different is implied by pictures such as "Sea-Sky" (1984) or "I am going" (1975). The letters are seen in foreshortened perspective, but the effect is not to undermine the illusion of depth; instead it is emphasized. The bold strokes fade into the whiteness of the writing, leaving space for the viewer's personal impressions of the poetic concepts and individual ideas embodied in the painting.

The verb form "I am going", which Bulatov has painted into a turbulent sky in the eponymous painting, defies precise translation. The Russian language has a number of forms for the verb "to go". Bulatov has chosen the one that

14

indicates a purposeful but uncompleted movement. The word sets the picture in motion by suggesting movement without firmly establishing its goal. The anonymous style of the typeface gives public access and general relevance to an intimate, personal action. A similar feeling emanates from the trellis of letters in "I live – I see" (1982), which imperiously directs the viewer's eye from the window of Bulatov's studio out over a bright cityscape of rooftops toward the golden domes of the Kremlin churches.

In an almost primal sense, he uses his art to hold at bay the terror of his environment. He understands beauty in Rilke's sense, as "the beginning of Terror", something which we can just barely manage to endure and admire "because it serenely disdains to destroy us". The aesthetic and ethical values embodied in Bulatov's paintings are as important as their sociopolitical content and lend them topicality and relevance that applies equally in our own cultures. Considered as an existentially significant visionary space, Bulatov's canvases provide insights into artistic activity in the East which we so ill understand, and are striking reminders that Russian tradition and Russian artistic independence are very much a part of European culture.

Translated from German into English by Material Word.

[1] Ilya Kabakov, "Am Rande", Catalogue, Kunsthalle, Bern (Aug–Nov 1985); Musée Cantini, Marseille (Jan–Mar 1986); Kunstverein für die Rheinlande und Westfalen, Düsseldorf (June–Aug 1986); Centre national des arts plastiques, Rue Berryer, Paris (Nov 1985–Jan 1987).

[2] Erik Bulatov, in A–YA, Unofficial Russian Art Review, No 1, Elancourt, 1979, p. 30.

[3] L. Pashitnov: "Without bureaucratic obstruction", Izvestia, 26 March 1987, p. 3.

Eric Peschler: "Beim Blick in den Spiegel wird vielen noch schlecht", art, das Kunstmagazin, Nr. 5, Hamburg, May 1987, pp. 12–13.

[4] "For Beauty's nothing but the beginning of Terror we are still just able to bear, and why we adore it so is because it serenely disdains to destroy us...", R.-M. Rilke, "The First Elegy (1912)", Selected Works, vol II, Poetry, translated by J. B. Leishman (London, Hogarth Press, 1960), p. 226.

ERIK BULATOV AND THE MOSCOW SCHOOL

Viktor Misiano

Erik Bulatov's generation was the first in the Moscow School to re-establish its links with the avant-garde art of the '20s that had been disrupted for so long, and, as a member of this generation, he shared the dramatic sense of shock experienced by those who successfully completed their studies at the Art Institute only to discover the utter inadequacy of the academic language in use there. In the search for creative renewal he and his contemporaries shared in their discovery of the Russian avant-garde of the early 20th century and an interest in artistic developments in the West. It is typical of Bulatov that his own development was influenced less by the widening of his artistic horizons through his education than by his personal contacts with Robert Falk (1886–1958), through the artistic and, equally importantly, through the moral example set by the latter. Through this relationship with the older Muscovite painter Bulatov was able to link up with the traditions of Russian Cézannism, and its methods of tonal fusion and harmonising of the various pictorial elements. At the same time Bulatov was preoccupied with the discovery of new means of reproducing reality.

By the mid-1960s, the excitement of newly discovered horizons in art at the Moscow School gave way to a more stable period. The majority of these artists found their identity in one or the other of the revived languages of the avant-garde. These ranged from social criticism in an expressionist style to various Abstract and Surrealist styles. During this period Bulatov's work underwent a decisive reassessment largely due to his personal contacts with a more senior figure in the Moscow art world, Vladimir Favorsky (1886–1964). It was not the practical works of this leading graphic artist and illustrator that were of such decisive importance for Bulatov, but his highly original theory of visual experience with its various speculative elements, and the principle according to which this theory can be creatively applied. For a number of years from 1963 onwards Bulatov's attention was focused on the problem of the painting as a complex organism subject to inherent laws. This necessitated a renunciation of Falk's teachings and of the underlying traditions that owed their origins to Cézanne.

After breaking with the traditions established by Falk, representing an entire era in the Moscow art scene, Bulatov entered a period of creative isolation. He maintained that it was necessary first to ask ourselves what constitutes a picture and what is our concept of the world, instead of unthinkingly adopting current artistic methods. In common with the most talented of his artistic colleagues, including Shwartsman (*1937), Yanilevsky (*1938) and Shteinberg (*1937), he also expressed his spiritual and moral doubts about the genuineness of the visible world, and shared with them in their efforts to delve behind the deceptive cloak of external appearances. This approach firmly placed his work within the context of the contemporary Moscow art scene. However, Bulatov's poetic creativity was not as radical as that of his friends, who postulated the construction of an autonomous artistic world, and who focused their attention on subjective mythologies and codes. Before we create new worlds let us grasp the appearance of the world that our eyes perceive! During this period Bulatov's sole protagonists were Oleg Vassilyev (*1931) and Ilya Kabakov. However, it soon became apparent that Vassilyev's main interest was on the transient subtlety of the perceptive process, while Kabakov's art was dominated by a leaning towards irony. Bulatov, however, implemented his creative programme with the unswerving earnestness of a man obsessed by the search for truth.

Bulatov's new period of creativity began in 1971, leading to even more pronounced divisions among the first generation of the Moscow School. The renewed inclusion of accurate details obtained from external reality in his paintings, and the increasing affinity between these elements and those of popular art, were considered by many as a betrayal of the high ideals that the Moscow avant-garde had been defending in their art with the dedication of martyrs. In so doing many of them overlooked the fact that, despite all the apparent differences, a firmly established organic link did exist between Bulatov's new works and his previous ones. His previous works had been concerned exclusively with an analysis of visual experience, and although they took direct perception as their subject matter, they were not a denial of that perception, but covertly used it as a premise. By choosing to tackle the strictly conceptual task of attempting to define the structures of the word, Bulatov even then transgressed the boundaries of purely aesthetic thought and showed a readiness to accept kitsch and popular art too. It is important to bear in mind that, to all intents and purposes, this new creative period was

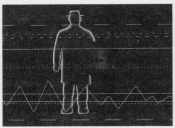

STREET AT NIGHT, 1966
94×110 cm / 37×43½"

URBAN PICTURE, 1966
90×122 cm / 35½×48"

a continuation of his ongoing dispute with his fellow protagonists in Moscow. As Bulatov himself stated, if we take reality as it exists, the truth is not hidden behind it, but is before our eyes.

From 1971 onwards Erik Bulatov's art provoked opposition from new quarters, from young artists like Komar (*1943), Melamid (*1945) and Kossolapow (*1943), who were just appearing on the Moscow scene. Although sharing the views of the new generation that art should not ignore the social and ideological context of the artist, Bulatov maintained that it would be erroneous to equate his work with the "Sots art" production of these younger artists. Bulatov had never taken any interest in the ideological mythology which the "Sots artists" were committed to investigating. Instead his attention was focussed entirely on an awareness of the world – the awareness of the commonplace, of everyday aspects. With the aim of revealing the hidden sources of our everyday experience, Bulatov subjected this awareness to the strictest process of reduction, dispensing with any form of emotional bias or any preconceived a priori concepts. If, in the process, Bulatov's work displays similarities with the banalities of popular art, this is because his major discovery consists of a recognition of the impenetrable compactness of the ideological world.

This interest in forms is considered by the "Sots artists" to constitute a fiction and a less than serious posturing, while their predecessor finds it impossible to regard a painting as fiction. Bulatov himself considers it the sole sphere of reality. The works of the young artists emanate from an unrestrained manipulation of meaningless ideologies. Bulatov's objective is to show that such ideologies are not dead but are very much alive, and because they are so entrenched in the hidden depths of individual awareness they cannot be circumvented. Such a discovery provokes not laughter but tragedy.

CITY AT NIGHT, 1967
100×130 cm / 39½×51″

New aspects of Bulatov's art are revealed in a dialogue with his works by certain performance artists, who revitalised the Moscow scene in the second half of the 1970s (groups such as "Collective Actions", "Nest" and "Fly Agaric"). By focussing their artistic interest on everyday aspects this generation of Moscow artists is to some extent coming closer to the heart of Bulatov's artistic creativity. However, their attitude differs in that they perceive these everyday aspects not only as objects of artistic assimilation but also as an area of creativity. Bulatov himself is unable to identify either with the efforts of these artists to eliminate the intrinsic aesthetic value of a work of art, or with their attempts to equate art with the commonplace, i.e. to structure art in a manner that is as fragmentary, random and unassuming as the everyday world itself. He accuses the new generation of a lack of professionalism, reproaching them for their moral carelessness and irresponsibility. Only a painting executed manually with strict intellectual discipline and careful reduction is capable of expressing the actual sense of the commonplace. Only in such cases do such commonplace aspects really become an everyday thing.

By the end of the 1970s and the beginning of the 1980s new directions came to the fore in the Moscow art scene. They consisted of an interesting if brief trend towards photorealism and a style of painting that can best be described as post avant-garde. The link between these two styles and the artistic works of Bulatov may seem tenuous, but nevertheless such a claim does appear to have some legitimacy, since the undisputable characteristic of such tendencies in an international context is determined by their affiliations to a particular school, and the origins of this school can be traced to Bulatov's art. The photorealist Aleksei Tegin confines his interest to the problems of light. This clearly distinguishes him from the adherents to international photorealism, but does provide a link with Bulatov's artistic

stance, since both artists equate the element of light with visible reality. In their view, light produces a wafer-thin layer of reality which they record on canvas, and it is this light that ensures the establishment of a connection between fragmentary presentation and a universal principle. And that is why the light on Bulatov's canvas creates an almost tangible reality, while Tegin's stream of light dissolves against the dazzling white background.

And finally, an affinity with the traditions established by Bulatov can be found in the work of Andrei Roiter (*1960), one of the youngest representatives of the new direction in painting among Moscow artists. This affinity is based on Roiter's fascination with everyday visual experience and its ensuing reproduction in a painterly context. He agrees with his older colleague that we must not seek the essence of being, of existence, behind things themselves, but behind their pictorial reproduction, because it is art alone that enables the essence of reality to be revealed. But whereas Bulatov's artistic method is based on a strict process of reduction and on self control, Roiter's art is an impulsive gesture, an emotional outburst. While the older artist endeavours to reproduce objects as such, unfettered by his relationship to them, the younger man consistently adopts the opposite approach: by treating objects as inseparably bound to the subjectivity of those contemplating them. The latter painter maintains that emotional appropriation is part of a mission to humanise the world, a moral obligation on the part of the artist. However, this view is yet another aspect that links the new art scene in Moscow with the achievement of Erik Bulatov.

Translation: From Russian into German by Ilma Rakusa, from German into English by Martin Scutt.

ON "PHOTOREALISM" AND THE PAINTINGS OF ERIK BULATOV*

Vsevolod Nekrassov

*The excerpts derive from an essay written on the occasion
of the symposium on "Photography and Painting", 1981,
for the Centre for Technique and Aesthetics.

There are two different concepts, the culture of the museum and creative culture, that, to some extent, run counter to one another: culture as the sum of knowledge and culture as accomplishment. (...) What concerns us is not the iambus but the life of the iambus, not painting but the life of painting. One may get by without the iambus, but not without life. The appreciation of a culture inseparably linked with the culture of everyday life, one that is also capable, and indeed prepared to perceive our everyday world in its entirety as culture, and to accept its authority, is based on this fact. In short, this implies taking an interest in the everyday world in its widest sense, encompassing the sacral and the routine, laughter and pathos. And, call it what you will, the everyday world includes God himself and our Common Experience. (...) I refer to those things that hardly require definition and explanation, items familiar to us all, that each of us can grasp and reconstruct with our intellects. They are so obviously manifest, and consequently (at least until recently) they enjoyed little esteem in a purely artistic context. (...) But now it has become apparent that the commonplace, these everyday aspects with which we are all so familiar, are no easier to attain as purely artistic objectives than other, similar objectives. (...) This confirms the validity of the observation that inner qualities can best be disclosed by examining external manifestations. In my view it is this interest that provides the real explanation for the art world's fascination with everyday and mass phenomena. (...) It would appear that we perceive a photograph "by ourselves" by means of a natural process, one that occurs automatically. But what if the quality of a picture painted from a photograph were something that could be automatically guaranteed...

We have not yet attained a state in which everything could emerge by itself, automatically, at the press of a button. Indeed, this "by itself" might well be the least automatic of processes, a thoroughly complex affair. It would therefore be naive to define Erik Bulatov as a photorealist. The existence of photorealism as it is understood in the West would be impossible in our country, one reason for this being the fact that photography enjoys a completely different status. Moreover, our habits and our skills are different too. In our society photography is not considered to be "by itself" as it is in the West, at least not in the same way or to the same extent. Our lives differ visibly and tangibly in form, mode and style from those of people in the West. Their concept of "by itself" and ours, i.e. the way of looking at standards and at the most commonplace things reveal little congruence with our own, at least not as far as photography is concerned. One reason is that photography as art is not so widespread in our country. (...) From our vantage point photorealism bears all the unmistakeable stylistic hallmarks of something "Western", and if it does not, then it fails to qualify as photorealism at all. Western artists regard so-called photorealism as a "new realism", whereas for Bulatov the photographic image, resembling a photo-graphic slide, is a one-off phenomenon. One picture ("Krassikov Street") suggests not only a slide but also a painting. Another for example "Seva's Blue", is more poster-like. And another ("I live – I see") again hints at a painted image. And yet another, a pair in a room in "plein air" style is very much like a colour television screen... I could name more, but the most decisive aspect is that, despite everything, these pictures have a greater affinity with each other than a resemblance to their original model. What links them most strongly is their matter-of-factness, what Bulatov refers to as their immanence. This sense of "how could it be otherwise", of "it goes without saying", is an aspect that I find so abundantly evident in Bulatov's work that it is difficult to accept it as something external, as being detached from myself... I do not intend to imply a similarity per se, but a paradoxical lack of definition in the sense of a similarity that defies accurate identifica-tion. It is apparently not something known, but yet it is understood...

Translations: From Russian into German by Ilma Rakusa, from German into English by Martin Scutt

Vsevolod Nekrasov, born 1934, lives in Moscow. Lyric poet (visual poetry, poetical objects).

"SEVA'S BLUE" "I LIVE – I SEE"
"THE POET VSEVOLOD NEKRASSOV"

Erik Bulatov

I would like to make a few remarks about the pictures: *Seva's Blue, I Live – I See,* and *The Poet Vsevolod Nekrassov.*
Naturally, these three pictures do not form a triptych: they have no – or almost no – pictorial similarity and yet they are related. What unites them is the work and person of Vsevolod Nekrassov.
Vsevolod Nekrassov's writing has exercised an immense influence on me. It is closely associated with what I do when I paint. Our common ground is our preoccupation with "platitudes", i.e. with things that are common knowledge, self-evident, obvious. Nekrassov's work is based on the living vernacular; it is not only his material but also the measure of the authenticity of his poetic voice.
The picture *Seva's Blue* is an attempt to transpose Vsevolod Nekrassov's poetry into the pictorial medium. Seva is a diminutive of the name Vsevolod. *Seva's Blue* (Sevina-Sineva) means: a blueness that belongs to Seva.
Nekrassov wrote a poem called *Blue* but I am concerned only with the shape of the word in a broader sense. I imagine a blueish white like the sky – sunny, windy.
I envisaged the picture without a bottom, so that both the top and bottom are the top.
The picture *I Live – I See* embodies a specific poetic and human attitude.
For the title of this painting I adapted Vsevolod Nekrassov's lines:

"I want not, and seek not
But I live and I see":
I interpret these lines as a formula for the artist who does not seek things in the world around him in order to judge or praise them, but who instead lives in his place and in his time as an observer of what life chooses to show him.
The artist's attitude towards his environment is irrelevant, because the present speaks for itself, it expresses itself through him. What is important in this expression is not the unique or exceptional but rather the most ordinary, mundane manifestations that need no justification, that will seem obvious to every contemporary.

Every age has its own characteristic accumulation of platitudes; they reveal what people believed in, what they hated, and what they found disturbing.
It takes time for these things to emerge, which is why we look with a certain condescension and indifference upon what people of the past considered vital and necessary.
Actually, we are of course neither better nor wiser than our forefathers. What we consider essential and self-evident now will gradually lose its importance and may someday even seem primitive.
We are immersed in our age. It pressures, torments, consumes us. It forces us to respond and take action. We are inca-

pable of seeing ourselves from without; we are not sufficienly detached.

Only the fine arts can bring about detachment. For me, it is painting, or rather, the picture, because the concept "picture" means more to me than the concept "painting".

Work on the structure of colours or the harmony of coloured surfaces does not interest me. The picture is different. It is the only reality I trust and believe in.

The world around us is too active, too unstable for us to maintain any true belief in it; everything is in a state of flux, everything is changing. Only the picture is immutable.

Its position in this world is unique. On the one hand, it is an object like a table, a chair or a plate. Like any other object, it has a surface, an edge, a certain hardness; it can be hung on a wall. But it is also a space which is distinct from the space where I exist.

If I want to orient myself in my environment, then I have to turn to pictures for help. They will answer questions that are properly put. Work on a picture is a dialogue. Nothing can be dictated nor forced. One must listen intently, or rather, watch the partner responding. The response consists of the picture showing me the appearance of what I want to know. That's the only way I can sense what I see but fail to recognise in life, time and time again. Now it acquires a shape and a name.

In fact, I think naming is the crux of the artist's work.

Everything else: attaching values, passing judgement – that is not his domain.

And finally, *The Poet Vsevolod Nekrassov:* you can't call it a portrait; it's a picture of course.

I want it to portray Nekrassov, the human being and poet; I want it to express the essence of his being which resembles the essence of his poetic word.

July 13/August 19, 1987

Translations: From Russian into German by Ilma Rakusa/Malgorzata Czyszkowska, from German into English by Catherine Schelbert.

ABOUT MY WORK

Erik Bulatov

I want to say something about my relationship to social reality and, in this connection, about the character of the picture I'm working on and about what I think is the main aspect of this picture.

Social reality affects us too directly for us to be able to see it as a whole. We can never be detached enough. We are always forced to respond, to act; our consciousness is absorbed by it and perceives it as confusion, as a bewildering activity that is shapeless and nameless.

At least that's the way I see it. Only through art can I recognize or distinguish something in this ceaselessly moving current.

An appearance can be endowed with a shape, with a name only through art. And when you encounter this appearance in real life, you recognize it, like an acquaintance who is named so and so and represents this or that.

Our consciousness seems to step back from the represented appearance of life in order to see it objectively, like something detached from us. Consciousness thus liberates itself from appearance.

That is why I try to express in art everything that affects me in life, i.e. I try to move it from its social space to the space of art. The problem of deciding what to represent is thus transferred from the professional arena to the arena of ordinary human perception: the more something affects me as a person, the more it absorbs my professional attention.

You might say that instead of my looking for the object, the object looks for me.

This implies a very important observation: in order to perceive, to grasp something in the current of social reality (which is the main constituent of our lives), we cannot have preconceived notions about our relationship to it.

If the artist approaches appearances with preconceived notions, then his art will reflect these notions, although they have nothing to do with appearances, which escape us and remain unconscious.

Interest lies entirely in how the artist evaluates the appearances of life, how he passes judgement on them.

To me, something else is important: the appearance itself has to be grasped, it is the appearance that counts and not my relationship to it.

In my opinion, it is of crucial importance that the appearance is depicted in the picture the way it presents itself to me as a person immersed in this world, without all those professional distortions and commentaries, without emphasis or exaggeration – just the way it is.

When I start to work on a picture, I try simply to establish a resemblance to what is being represented, but I don't know the appearance itself anymore than I know how the picture will turn out. The two processes run parallel. The flash of insight into a picture is like the flash that illuminates the essence of the object to be represented. So that's it. Now I know it.

25

ENTRANCE, 1972 120×120 cm / 47×47"

When this happens, the picture is finished.

But how does the picture illuminate the object of representation?

I imagine the space of such a picture as a hallway connecting two rooms, the space in front of the picture, and another one behind the picture, my social space and the viewer's.

An endless flow of light moves towards us from the space behind the picture. It is permanent, and, in the permanence of its motion, motionless.

This is the support, the foundation of the picture, its moving force.

If the object of representation makes its way into the picture from the space in which I find myself, then it is illuminated by the on-coming flow of light and perceived by my consciousness.

What role does the artist play in this process?

The artist need only be alert. During the preliminary work of making the first con-structions, it is imperative not to cut off the vital connection with the immediate impression and the perception of reality. This becomes even more important when working on the picture itself, where the only goal is to permeate it with light, drench it in light until the tables are turned and light creates the representation.

The artist must do his best not to interfere in this process, not to allow his personality to intercede, i.e. he must suppress all conscious influence on the process. For if consciousness is given free rein, it will automatically bring some pre-determined, pat solution to bear, and life will atrophy; everything will be false.

If it is possible to ride the wave of alertness, if the picture succeeds and is finished in a flash of knowledge, then what is vital and important in the stream of reality has been grasped and captured. Then my consciousness as an artist is freed and separated from the representation and my consciousness as a person is freed from the represented appearance.

From everything except light itself. Light will never adhere, will never coincide completely with that which it illuminates. By permeating and filling everything, it also stays in its own space.

More precisely, the space of light is larger than the space of our life because it encompasses our space as well as the space behind objects, behind the picture out of which it emanates.

That is why light is constant. In fact, light is the only constant and we can never escape it.

Freedom from light is the same as freedom from freedom: complete darkness and chaos.

Light, the movement of light, is therefore the focus of my work.

The character of this movement, the spectral differentiation of light in space, the character of spectral shifts while light is forming the objects – that is what I work on, what I am trying to explore with the greatest of care.

April 1984

Translations:
From Russian into German by Madeleine Rollier,
from German into English by Catherine Schelbert.

PLANE – SPACE – LIGHT

Erik Bulatov

1. Object – Space

Apparently representational art has always been faced with the question of how to orient itself amongst the infinite multiplicity of forms and appearances of the visible, perceptible and sensual world.

This automatically generated the necessity to classify and to define the periphery, the boundaries of the world.

The most obvious and simplest approach proved to be the assumption of two poles; the concept of the object, on the one hand, and its complete non-existence, i.e. space, on the other.

After all, what could be more diametrically opposed than the object and its absence? Nothing. Thus the poles of the visible world are given. Everything else is located inbetween as gradations and crossings between the two poles.

The concept of "space" is far from amorphous: its relationship to the object is complex and multifarious.

It can be aggressive and can distort the object – the ensuing struggle can generate drama, tension (El Greco); the object can be the meaning, the focus of space (Classicism), or its victim (Expressionism), etc.

The object stands in space the way the artist stands in the world. Consequently the artist needed to engage with the object by defining the relationship between object and space. The artist was expressing his relationship to the world, his Weltanschauung.

Every object consists of surface and volume and thus presents a complex unit. What happens when we replace the conceptual duality "object-space" with another one, e.g. "surface-space"?

Imagine the image of the world presented to us through the window of a moving car. Through the side window, we see the world in profile. Everything is moving – albeit at different speeds – either towards us or with us but always parallel.

The world through the windscreen is so categorically cut off from us that we have absolutely nothing to do with anything that is happening in it. Basically, we per-

ceive it as a plane although we obviously know that some objects are closer and others farther away.

Whatever happens in this separate but parallel world, it is no threat to us; we can observe it serenely and aesthetically.

That is the image of the world presented to us by its surface.

The image unrolls before our consciousness like a film. It has only one deficiency: we gradually become bored and begin to look through the windscreen in front.

Here an entirely new picture opens up. To begin with, there's the street along which not just anybody but we ourselves are moving. The street dissects the entire visible space, reaches to the horizon and even beyond it. Everything that happens in this world and, in particular, everything happening on the street is either moving towards or away from us, but is always in relation to us.

It is the world en face.

Here nothing is indifferent, everything affects us directly, and the windshield seems to give us no guarantee of safety. It soon becomes obvious that we are no longer perceiving anything in the world around us. Our attention is focused on the road; more precisely, on ourselves moving down a road that is an imminent and ceaseless threat to our lives.

We are no longer concerned with aesthetics but neither can we tear ourselves away from the image in front of us: it is never boring. It is basically the image of the world that is presented to us by space.

Actually it is not the image of the world but a striving beyond it, a signpost. It is in fact equivalent to our own movement through the world.

Perhaps we can enlarge on this metaphor to take a closer look at what the world of surface and the world of space mean, as I see them.

2. Surface

Surface, which by its very nature seeks to circumscribe, cannot tolerate the existence of something that lies beyond its borders, that is undescribed, extraneous. This would amount to conceding imperfection.

The world of surfaces can only exist in space, otherwise surfaces would flatten out into mere planes.

Space makes room for objects and fills them. It is in and around us. It is everywhere. It enables us to breath, it is expanse, and, finally, it is freedom.

Were it possible to define space, I would call it the possibility of moving through the world.

But let us return to the image of the car, to what we saw through the windscreen.

I contend that space does not actually contain an image of the world. It raises doubts about what is beyond the horizon; it believes that something is there and that this something really is reality. By its very nature, space negates everything finite, everything that is limited. Its ideal is infinity and it strives to get there.

We are afraid in a car because our movement through the world is in effect nothing but movement towards death.

Space by itself, just like surface, is death. Although they oppose each other everywhere, it is only because they exist simul-

taneously that space and surface form life, i.e. that form of existence which is accessible exclusively to human consciousness.

Surface cannot live without help from outside although we do not at present know where it will come from. Space is by contrast a kind of signpost although we do not know where it is pointing.

And it seems to me that there is a point in the art of every period and for the people of every period that is the one immutable point of measurement, the one fixed point of departure – and that point is light.

I contend that the idea of an object and of space is subject to change, so much so today that objects have become irrelevant, but light, although it has been approached differently in different periods, is immutable.

The entire visible world can live only through light but space is the path of light: without light there is no space.

Surface, although it also lives on light, through its energy, is always an obstacle on light's path: the ideal surface allows no light to penetrate, it either reflects or absorbs it.

Thus surface is naturally opposed to light.

It obviously follows that surface, i.e. our entire objective world with its surrounding space and our entire social world as well, in a word, everything, is to be found at one pole of the world.

The other pole is light.

Space is the mediator between them; light penetrates the world of surfaces through space.

3. Light

The picture must possess its own light; color itself has to be luminous, otherwise it will lie dead on the surface of the picture and all we will be able to see is isolated colour out of which nothing can emerge.

The moment light comes into play, the image comes to life and is transformed into the illusion that is the reality of art.

The source of light is always located outside of the illuminated subject. Light must therefore have a source beyond the boundaries of our world; it must be larger than the world.

This is the immutable, though invisible reality that is the concern of art and upon which our consciousness unwittingly relies.

It exists beyond all social existence.

But this light is inaccessible to art.

Other, higher levels of consciousness have the ability to establish direct contact with it.

Art, however, is an earthly affair.

It can only make contact with light via surface, i.e. through concrete situations or, as we say today, through concrete social reality.

If the source of light is always located beyond the world, what does it have to do with our problem?

After all, we were talking about poles, about the boundaries of the world, and not about what exists beyond them.

It seems to me that our world of consciousness has expanded. Its boundaries have outgrown the objective world.

There is really nothing in the objective-social world for our consciousness to rely on, nothing we can trust. It does not

TWO LANDSCAPES WITH RED BACKGROUND, 1972–74 110×110 cm / 43½×43½″

follow, however, that the whole world has become undependable, but only that it is not the whole world.

By calling the artist's awareness in our century cosmic, Matisse pointed out how open modern perception of the world is, in contrast to the closed world-view of the past.

It is my contention that the light beyond the boundaries of the objective world is located within the boundaries of our world of consciousness, or rather forms the boundaries of that world; it is the pole which opposes surface.

(abbreviated)

Bulatov 1981

Translations:
From Russian into German by Madeleine Rollier,
from German into English by Catherine Schelbert.

THE SPACE OF THE PICTURE

Erik Bulatov, 1988

Recently, I have been the subject of some writing which has enabled me to observe the desire to subsume my work within a precise artistic tendency — photorealism, conceptual art, pop art or even academic art. This compels me to define my artistic position.

My view of the world is shared with Oleg Vassiliev's. Together we have developed some principles and we have supported each other for years in order to continue. If I use the word I rather than we, I do so in order to avoid giving the impression of elaborating an artistic programme when I want simply to evoke my daily work.

All artistic judgements depend on the criteria used. In my opinion, the principal criterion in the field of the plastic arts is the artist's conception of space. In fact, this conception of space determines our conception of the world.

It is precisely from this point of view, I would suggest, that I should be situated within the contemporary art scene.

Today it is acknowledged that art does not pursue one single direction as was still thought at the end of the 19th century and even at the beginning of the 20th century. Today it seems that art follows a number of directions and utilizes many languages. However, if a concept of space is our starting point, it is possible to see things differently.

Until the first half of the 19th century, the concept of space was reduced to the plane of the picture. The characteristics of this space inevitably corresponded to a given epoch, the space as analogous to human existence.

From the second half of the 19th century, art gradually liberated itself from this dominant conception of reality. Consequently the deployment of colour, the actual plane of the picture began to acquire an autonomous meaning. The revolution at the beginning of the 20th established that the plane, the structure, the colours of the canvas could become the sole raison d'être of the picture. Space had been restrained by academic conceptions. Now it was liberated.

31

Michael v. Graffenried

The space of the contemporary picture seems to oppose itself to the space presented in the academic picture. It rolls towards us and merges with social and psychological space – the space of our existence. The boundary between these two spaces is not easy to percieve. So, a certain conception of space can engender a certain conception of the world. In this sense, we are concerned with a schema which, though simplified, expresses the specificity of this contemporary conception of space, a conception which has already become, in a certain sense, traditional.

I am not prepared to repudiate nor ridicule the active role which the picture has, the way in which it challenges the viewer to review its creativity. Nor will I countenance a hermetic conception of the closed space of the academic picture from which the viewer is excluded. For me, the space appearing on the plane of the picture is an absolute reality, more real even than the space in which I live. In the space of everyday life, nothing is certain, everything moves, changes, is in a state of flux. By contrast, in artistic space, the passage of time is suspended and everything becomes immortal.

Therefore, I can reject neither the space around us (never mind whether it is real or the product of the viewer's imagination) nor the space which heads

for the depth of the picture. Consequently the space of the picture I paint must spread to both dimensions – on the one hand towards us, towards the space of our daily life, and on the other hand towards, and within, the space of the picture itself.

Between these two spaces is situated the plane of the picture which determines their boundary: the degree zero.

The most convincing examples of this simultaneous representation of these two spaces, and the balance between them are the pictures Glory to the CPSU!, Entry, No Entry, Danger, etc.

It is nevertheless possible that only one of these two spaces is represented in the picture, or more precisely, that the representation of the one completely dominates the other (still existing, but appearing to the viewer no longer as the represented image, but as its content.)

Where only the specific space of the picture is represented *(Natasha, Rue Krassikov)*, the essential thing is that the viewer perceives the picture as a familiar, recognizable object. Its nature is not critical: poster, postcard, photograph or popular painting.

In looking at this kind of picture from outside, as a familiar object, the spectator must simultaneously regard it from the interior as a real space. If that is the case, the picture lives and acts. On the other hand, if all that is represented is this enacting space, the space of the picture becomes the essence of one's own perception. Then, the space directed towards us can seem aggressive as if it wanted to invade the space of our everyday life.

However, we never perceive it as real or unique, despite our certainty of the existence of another space which, although distanced, never disappears.

It is therefore this duality of the space in the picture – these two elements which are opposed, but which are necessary for their mutual definition – which determines the very existence of the picture.

This point of view affects our vision of art: For example, my pictures and Oleg Vassiliev's which bear absolutely no resemblance from a traditional point of view, can be established through this attitude not only as related, but as a united investigation of the same problematic. To my knowledge Vassiliev and I are the only people to construct such a space. The two of us therefore represent a kind of artistic current.

Translated from Russian to French by Stanislas Zadora; from French to English by James Lingwood.

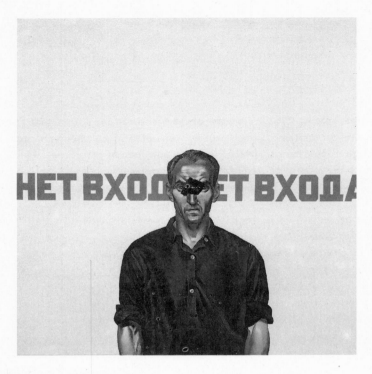

SELF-PORTRAIT (THERE IS NO ENTRANCE), 1973 110×110 cm / 43½×43½″

MY BIOGRAPHY

Erik Bulatov

My father was born in 1910 in Saratov on the Volga. On completion of his secondary education in 1918 he was immediately caught up in the Civil War. After the war he became an official in the communist party.

My mother's birthplace was Bialystok in 1907. In the aftermath of the Revolution and the re-establishment of the Polish State, the city again became part of Poland. By nature a romantic, she had no time for a comfortable petit-bourgeois lifestyle. The Russian Revolution aroused her admiration and at the age of fifteen she fled illegally across the border to Russia.

My parents first met in Moscow, where my father was employed by the Central Committee, while my mother had become sufficiently proficient in Russian to train as a shorthand typist.

My father was sent to the Urals on official business in 1933, accompanied by my mother. I was born there, in the city of Sverdlovsk, in 1933, but I have no other ties with the city apart from a brief stay there during the War. My family returned to Moscow when I was three.

In 1938 my father commenced work as a scientific secretary in the editorial offices of the Great Soviet Encyclopedia (having had the benefits of a secondary education).

In 1941, immediately after the Soviet Union entered the War, he was sent to the front and fell in 1944 at Pskov.

It was from my father that I acquired my love of poetry, and he was so certain that I would become an artist that he was able to convey this conviction to me.

My first steps, in fact my entire education, were typical of those times. First I attended a drawing class of the youth organisation, "Pioneers", followed by a period at the Moscow School of Art (of which I retain the strongest memories, and to which I am greatly indebted), and finally, from 1952 to 1958, I studied at the Faculty of Painting at the Surikov Institute.

The period in which I completed my schooling and commenced my studies at the Institute was a very difficult one for the arts in general in our country. Not only were we unfamiliar with the Russian avant-garde, but the whole of European art from the Impressionists onwards had been banned from the museums. And turning to Russian art, even the works of Vrubel and Korovin were prohibited.

With the death of Stalin widespread changes occurred, but the effects were not apparent in our painting courses at the Institute, where the same Stalinist teachers were teaching the same things.

This explains why many students, including myself, became increasingly disillusioned with what we were being taught, aware that it was not true art, and that all our acquired skills were useless. Moreover we realised that genuine artists did exist, who were privy to the secrets of

35

the true art that was being denied to us. Such artists, however, were not to be found teaching at the institutes. Nevertheless they did exist, and it was our task to locate them.

It was in this way that Robert Falk and Vladimir Favorsky became my real teachers. Together with friends, including Oleg Vassilyev in particular, I paid frequent visits to these artists, and I am convinced that they had a decisive influence not only on our artistic development but also on our awareness as human beings.

At the Institute I was a good student, participating in an exhibition by Muscovite artists, and in 1957 my painting "At the source" was exhibited in the Soviet pavilion during the World Youth Festival in Moscow.

Nevertheless, after completing my studies at the Institute, I realised that I had to undergo a re-learning process. To safeguard the integrity of my artistic development and provide myself with an income, I took a part-time job. Assisted by Ilya Kabakov, Oleg Vassilyev and I studied to become illustrators for children's books. This was the beginning of my professional involvement with this particular area, in collaboration with Oleg Vassilyev.

This re-learning process occupied me until about 1963. Although my paintings subsequently underwent quite a radical change, I still believe today that my work since 1963 no longer consisted merely of an evaluation of alien experiences, and that I had finally found my own idiom.

My first attempt at exhibiting my own work took place in 1965 in the Kurchatov Institute for Nuclear Physics, where my paintings and those of Vyacheslav Kalinin were put on display. The exhibition remained open for just one hour and was then immediately closed down by the authorities.

In 1968 I had two one-evening exhibitions in the "Blue Bird", a café for young people, the first in collaboration with Ilya Kabakov and the second a one-man exhibition.

I only participated as a book illustrator in the exhibitions organised by the Artists' Association, and it was in this capacity that I was accepted into the association in 1967.

Dina Vierny presented an exhibition of artists from Moscow in her Paris gallery in 1973, with paintings by Kabakov, Rabin, Yanilevsky and sculptures by Arkhangelsky. I was represented by my "Self-portrait", painted in 1968.

My painting of "The poet Vsevolod Nekrasov" was exhibited along with works by other painters for several days during a conference on the subject of "Photography and the visual arts" in the Centre for Technique and Aesthetics in Moscow in 1982.

During the same year I was allowed to exhibit my paintings "I live – I see" and "The poet Vsevolod Nekrasov" in the municipal museum in Tartu (Estonia).

I was able to display the occasional painting at exhibitions in the Artists' Association clubrooms, but each showing only lasted for one evening.

In 1986 I participated as a member of a group of artists in the exhibition hall of the Moscow section of the Graphic Artists' Association in the Malaya-Gruzinskaya Street, where my painting "Welcome" was exhibited.

In 1987 the painting "Trademark" was exhibited for the first time at a show presented by the Artists' Association in its new exhibition rooms in the Krasnogvardeiskiy Quarter (near the Kashirskaya metro station).

The inclusion of my painting of "The poet Vsevolod Nekrasov" at the Chicago Art Fair in 1986 was an important event for me.

April 21, 1987

Translations:
From Russian into German by Malgorzata Czyszkowska,
from German into English by Martin Scutt.

INTERVIEW WITH ERIK BULATOV AND ILYA KABAKOV, MOSCOW, JULY 1987

conducted by Claudia Jolles
Interpreter: Viktor Misiano

Claudia Jolles : Could the motifs in your works such as the window, sky, snow and sea be considered as specifically Russian symbols?

Erik Bulatov : As far as the window is concerned it is fairly obvious: it divides the space into two parts. It is a kind of symbol, at least that is the way I see it. In the painting I see a space other than the real space in which I live. The painting is a surface but it also indicates something else. Of course in view of the concrete nature of the world, the sky is the most evident symbol of this. And then there is snow: this is concerned with our lives. The whiteness embodies light on the one hand, and death on the other. Moreover snow is a kind of boundary. I think it is this border situation that interests me, this transition from one space to another, since this corresponds with my present situation. I am interested in objects standing on the boundary or defining a boundary.

Ilya Kabakov : I would agree with what Erik has said: the boundary as a place of transition, as a conflicting situation. Life here, especially my own, is dominated by the archetypal feeling of being in an enclosed space. In a certain sense this space is the life within us. It is not a pleasant feeling, this fear of what is going on outside of us. The window, the sky, the snow, are where man ends up when he goes outside. Passing through the window he directly enters the immense space of the sky or of the snow. It is grotesque that we are so concerned with this window: we fly through it, without spending time on the surface of the earth.

Claudia Jolles : It would appear for both of you that the painting is important primarily as an illusionary space.

Erik Bulatov : Yes, even if one compares Russian and Western European paintings from the 19th century, a distinction is recognisable: In the West a painting is basically a correctly fashioned object (disregarding questions of quality), whereas in Russia it is a challenge.

Ilya Kabakov : What counts with us above all is the way the painting is understood. Its value is not in the thing itself but in its interpretation, its message. We do not judge the object, but what it tells us.

Erik Bulatov : Our art is concerned with problems that are not so relevant to people on an artistic level, but in their everyday lives. What matters about a painting is not its conceptual aspects or the way in which it has been

created, but the problems it embodies. Art here (in Russia) has always been associated with our lives. It could be described as a national need.

Ilya Kabakov : Here one always expects an answer to specific questions. Our friends, artists who have travelled to the West, experience this as a problem. Believing that similar expectations exist on the other side, they are shocked to discover that this fundamental support in artistic life does not exist. It puts them off balance.

Claudia Jolles : How do you reconcile the realistic tradition of the 19th century with 20th century abstraction?

Ilya Kabakov : I do not see a contradiction here. Sooner or later the two traditions will have to unite, although this has not been the case so far. Even when Russian art was at its zenith, i.e. under Kandinsky, Chagall, especially at the beginning of the 20th century, this was of only peripheral importance. That was because these artists transformed art into something else: the dominance of the means. In this respect art was superior to the human question. I believe that it is quite easily and naturally fitted into a supranational artistic activity. And, as the artists of the avant-garde put an end to traditional Russian art, its national aspect became obsolete too.

Viktor Misiano : Wasn't the "life constructing" pathos of VCHUTEMAS[2] a synthesis of the Russian attitude?

Erik Bulatov : No, I don't think so. Of course it was Russian, to quite an extent, but it was also very much linked with its own age, occurring at a time of general disintegration, a general process of destruction and the projection of a new existence, a new world. And therefore, there was no connection at all between man's achievement and this everyday existence. Quite the contrary: people closed their eyes to it. They could see what was going on in the country – it hit them right between the eyes – but it did not affect their art.

Only Shostakovich, Mandelstam, or Platonov were able to deal with it. It is there, in literature and in music, but not in the visual arts.

The people suffered, the artists were appalled, but they endeavoured to forget everything and live their own lives in a different space, somewhere up in the clouds. Reality was replaced by a fictitious existence. Traditionally people in Russia turn to artists for guidance in times of trouble. The artist is expected to translate life's problems into art. And this applies to me as well: but only when I have identified a problem in art can I also perceive it in my real life, because in reality we see and understand nothing at all. There is a widely held view that art can only be understood if we are familiar with its social surroundings. However, I believe the opposite to be true, i.e. that it is unnecessary for art. A social reality can only be comprehended through the art of its respective era. In

El Greco's case, for instance, some knowledge is of course required in order to understand certain theological or literary aspects of the paintings, but this does not make them any better or any worse. If when looking at the painting of burning candles I am also aware that people were being burned like candles, this helps me establish a historical context. The painting becomes an image of its age; an understanding of the age, of its social reality, becomes possible through art. This is not possible in life as we experience it. We can not recognize life itself. In fact, I am convinced that we are not able to directly perceive natural phenomena. We only see the sun set because it has already been depicted.

Ilya Kabakov : I should like to say a few words about the way in which 19th century Russian Painting, i.e. the traditional depiction of reality, became reconciled with the Constructivism of the 1920s. How were the two brought together? I should like to approach this question in the following way: in the 1920s and indeed throughout the early years of the century, a massive restructuring took place, accompanied by a burgeoning optimism. Constructivism and other artistic means of expression were discovered by great artists in expectation of a new era. They were convinced that this era had already begun, ushering in a new type of person, and that the boring centuries that had preceded, populated by all the Pharaohs, by the Tsars Nicolas I and II, were a thing of the past. At the beginning of the century we were full of illusions about a spiritual and material restructuring that would affect the whole world. The revolution was just the fuse, but the bomb that it was expected to ignite would one day explode the whole world. Russia was just a victim which offered itself up in order radically to change the whole of mankind.

It is impossible to comprehend this insane enthusiasm unless we appreciate these maxims, and the extent of the megalomaniac, superhuman idea of changing the world. But to us this utopia has become bound up with another. It is not only aimed at the indeterminate future, but also refers to the deeper reaches of the nature of mankind that predate man's existence altogether. It is no coincidence that in the early avant-garde there was a link between Khlebnikov's futuristic ideas about the flights to new stars and the language of animals or our prenatal existence. Our future life may be uncertain, but everybody agrees that there was once a paradise. The nucleus and the strength of these utopias is to be found in the combination of a future existence and this prehistoric paradise. The future will present us with this paradise and will combine with the past. Only the present does not exist. What does it matter when a painter such as Filonov starved to death because he did not receive any more food stamps or food, if everything that matters happens in the future. Our

generation arrived after the utopia had been accomplished, and after the cooling off of the nuclear explosion. Radioactive fallout has descended, and we have rediscovered ourselves in a post-utopian world. We are the heirs, the amazed witnesses . . . It is our task to describe the state of mankind, of the world and of our own psyche in this post-utopian world.

In this connection it is interesting to note that the end of this great utopia was not accomplished by the catastrophic demise of utopianism as such. I am compelled to draw this sad, almost tragic conclusion, with its implications for our generation. No major change has occured in the principle of utopianism: the great utopia has exploded, leaving us with some small, tiny utopias. Contrary to the hopes expressed by Malevich or Kandinsky, we have failed to come together. Now we endeavour to be united, at least in a small group, and to continue to live well.

It is my desire that my painting should also depict a kind of paradise, even if that paradise should contain some faults. In this respect I no longer consider it the purpose of art to depict awful megalomaniac entities, but to describe no less pitiful but slightly more pleasant, present day achievements. A modest celebration, a hint of paradise, a small illusion of reality still remains. And that is why the problem of language assumes such importance. It describes certain distant places, landscapes, pleasant subjects of a simple life. Everyday existence itself is seen as a kind of utopia. To a certain extent it is the task of our generation to expose the bitterness, the fiction of a utopia, even a minor one. This is no less frightening than the dethronement of the great utopia – like the fight with the rat after one has overcome the big beast.

Erik Bulatov : I should like to add something here. In spite of everything the relationship with the world has changed drastically since the time of these global utopias. Subsequently the system in which we lived endured because it was impressed on everyone that the world in which they lived was absolutely unchanging, a world where everything would remain the same. This is what constituted paradise. Life would continue to develop only where no paradise existed, provided conditions there were not the same as they are with us. The change that has occurred in human consciousness is that mankind regards its nightmare existence as paradise. By this I mean that my problem does not lie in a desire to alter or improve the world. We are cursed in that we cannot touch all of this. If you want to involve yourself, you have to devote your entire life to it. This is no longer art, but becomes an activity that seeks to change this life. But if you involve yourself with art, you are not allowed to touch upon these things. And this is where our position differs completely from that of the artists in the West. Let us take Picasso, the supposed master of the objective world. He had the facility to do what he wanted.

He was concerned with transformation, he distorted every object. This is typical of the consciousness of the free person. Why can we not use him as an example? Because our psychological make-up is not that of free people . . . Our task and the task of our generation is to show that this world depicted as unshakeable, immutable, eternal is not everything. This apparently immutable world here is in fact false, ephemeral and untrue. Real existence is to be found on the other side of the boundary. This explains why that space beyond the picture is so important to me too. For me it is the true existence. The fact that this space exists proves the limitations of the world here. It is static and unchanging but not limitless – and that is its primary feature.

Ilya Kabakov : Its unity is unbroken and there is nothing else.

Erik Bulatov : There are no cracks in it.

Ilya Kabakov : In the horizontal plane it is infinite, but not in the vertical plane.

Erik Bulatov : And that is the difference between us and all of the other artists who oppose Soviet power, such as Komar and Melamid or our emigré writers. Their subconscious is so conditioned that an entire world can be described using their system of symbols (i.e. those of communism and socialism). They don't ask themselves: Is this the whole world? To them it really is, they merely reverse symbols: the world is not good, but bad, there are holes in it. The communist consciousness remains intact, and only the symbols are exchanged. This differs fundamentally from our consciousness . . . we don't believe that it is necessary to change the entire world, only that it is important to regard it as totally false. We use a different language, and this is a complicated business . . .

Viktor Misiano : But you see the language of official art . . .

Ilya Kabakov : I feel that in using this language we regard it as a reflection of a dishonest situation. This is an astonishing paradox. We know no other language, and yet we know that this language is totally false. We have found the described world in a canonised form. There are some good reasons why we were educated at art institutions where we were taught a uniform, complete and definitive system of representation, a system that was similarly obligatory in literature and politics. And yet beneath this armoury our generation suffers. We have to realize that we only have one language at our disposal, one with which we are really incapable of speaking because it is so fictitious and false. One might just as easily use the language of French painting or of the Impressionists. Today it is obvious to us that no universal language exists that can express truth in its multiplicity.

Erik speaks that language that is rooted in our consciousness. He speaks using the shapes and symbols which are given to us, but he makes them relative and renders them transparent. The tension between

language's claim to express everything and its limitations are a characteristic feature of our generation.

Erik Bulatov : Language fulfils a dual role for us. Firstly it is the language of power, and it is also the language of our everyday lives. We speak with it, we use it to think with. It is the tuning fork of authenticity. It is our loyalty to language that determines whether a person or an artist is honest in his art. It is essential to constantly focus our attention on language, which one should always use to correct what one is doing. If an artist begins to speak in the language of the Impressionists, the Cubists etc. he loses everything, because that is not his language, it is translated. And everything that is said using it relates to a different world and to different problems. Every shape responds to a certain content. If it is used differently, as for example in Russian art in the 19th century, the result is an incomprehensible mess. Art of this kind is redigested, epigonous, ignorant of the noble intentions of the artist. No matter how great the discrepancy between our language and what we are trying to express, we should not reject our language. On the contrary, we must build on this discrepancy.

Ilya Kabakov : It is one of the phenomena of our age. We can choose any language we want from such a large number. When Erik includes letters of the alphabet in his paintings he is using at least two languages, i.e. that of the text and that of the painting. But which of them is Erik's language? It is a language of collision. Because we know many languages, we find our identity in their interrelations, in their dialogue and in the way they clash with one another.

Erik Bulatov : I should like to return to our problem: it concerns our perception of this world as a single entity, i.e. the adoption of a viewpoint enabling us to experience it not only in its entirety, but in its limitations too, even if we cannot change this world. In this respect everyday speech is vitally important.

To use a musical analogy, it is the tuning fork that establishes the right tone and leads us back to the actual problems. The common human dimension is important, and we are expected to give it a name. In my view that is the task of the artist. For the artist the unsophisticated eye is the equivalent of everyday speech to the poet. It prevents us from stumbling and helps us to establish where we are.

Ilya Kabakov : Our problem is that we have received an elitist artistic training. We should have been priests, filling up the receptacles of oil at the altar and swinging the censers. And the background to this training is our awful everyday life. It was suggested that we study landscapes. But what are we supposed to do with our kitchens, with our mothers, with our shoes? It is this return to aspects of our everyday life that distinguishes our

work from the academic art of the 19th century. Every serf, every out-sider, every parvenu was accepted into the academy and put into uniform: they climbed the academic steps and painted sacred motifs. To a certain extent this tradition continued under Stalin. We ourselves stood on the lowest step and were expected to ascend to the glittering heights of the academy. Now we . . .

Erik Bulatov : . . . have broken though certain aesthetic stereotypes to find our own language . . .

Ilya Kabakov : . . . Not an artificial language, but a human one . . .

Erik Bulatov : . . . and allow it to speak in the world of art.

Viktor Misiano : That means that you grant it the status of reality?

Erik Bulatov : It is a matter of similarity, similarity of experience. Not in the sense that I might draw a cup and it would be recognized as such, but so that someone would be conscious that this is my life.

We can approach reality in art in one of two ways, depending on how the artist behaves, on how he evaluates it. He either praises or denigrates this or that situation by distorting reality. In this case it is this attitude that is important, and he has to convince the viewer. Or else his judg-ment is unimportant and it is reality that has to express itself through the artist. This is the situation in which Ilya and I find ourselves. For us art is not a reflection, it is a method of understanding.

Ilya Kabakov : We are saturated by interconnections to such an extent that the act of showing one simple real thing is relevatory. Paradoxically it is often the case that an insignificant thing contains some greatness. It is not without good reason that Russian literature repeatedly focuses on the problem of the "little man" on whom, like Gogol's Akaky Akakyevich [3], everything is inflicted, but who is barely capable of self-expression. It is not a matter of pity, but of a human dimension in contrast to the monumental question of the "eternal truth", of the "eternal restructuring of the body politic" . . .

Claudia Jolles : What features distinguish Moscow from other Soviet cities?

Erik Bulatov : Moscow is the centre, the capital. Our work is concerned with ideol-ogy, with the ideologising of awareness, of language. This is not a problem that one can avoid. Perhaps it should be regarded as a kind of object, but probably that is only feasible here, where the controlling force for everything remains visible. It would be very difficult to com-prehend this power if we were only able to see its symptoms. We are always able to refer back to immediate experience.

Ilya Kabakov : Like all our artist friends, neither Erik nor I are able to move some-where else. If we could move to somewhere else at least from time to time we would be able to view matters from a different perspective. But we are condemned to sit in our studios forever. And they are in Moscow.

Since we turned our attention to problems specifically concerning Moscow, we have rid ourselves of our provincial inferiority complex, and we feel that we are in the centre of the football field, so to speak.

Erik Bulatov : It certainly is not provincialism. Only if we were to attempt to follow the river of all the world's arts from this location, and try to drift with it, would this reflect the provincial attitude that has predominated for such a long time here. But by regarding life here as something special, we have shaken off this attitude.

Ilya Kabakov : Moscow, the centre of Moscow, generates a tremendous energy. It is not without good reason that Erik painted the work "I live– I see". It concentrates on this centre that energises us.

Erik Bulatov : The predominant complex in Leningrad is quite different. The city's cultural past is so strong, even its architecture, that it is difficult to appreciate one's own existence as something real.

Ilya Kabakov : This question of the city, of the city's energy, is an interesting one. We no longer experience the city the way it was seen at the beginning of this century, the dreadful buildings, the urbanism, what the German painters Maserel and Grosz referred to as the "Spider City" or the "Octopus City". Everything around us is fictitious.

Erik Bulatov : How can we believe in the reality of a building if there is a chance that it may be blown up tomorrow?

Ilya Kabakov : Or believe in a building that is being renovated, even if during this renovation it starts to deteriorate again.

Erik Bulatov : The real environment in its entirety is ephemeral to us. Ideology, on the other hand, is an absolutely real force, a metaphysical energy capable of reorganising everything in a flash.

Claudia Jolles : What are your views on the current generation of young artists?

Ilya Kabakov : That is a difficult question, but of course I regard the younger generation with great enthusiasm and have a great sympathy for them.

. . .

I do not share in the hopes expressed by many others that the recent liberalisation will cause the "underground" to disappear and to break up into new, joyous and unrestrained production, nor do I think that this will come to pass in the near future. Unofficial art has produced a number of new generations, each showing a respect and sympathy for its predecessors. They regard themselves as a link in a long established tradition. A certain line of development is apparent in unofficial art. A situation evolved here in the 1960s and 1970s in which, despite all the difficulties, certain results were achieved which now can be considered typical of this country in its present situation.

Today the more universal, international and typological problems that confront us in magazines, through personal contact and the sale of

paintings tend to dominate, at the expense of particularly local features in art, specific to a certain area.

Erik Bulatov : It appears to me that, with all the diversity to be found in the "underground", serious evidence of a boundary is becoming apparent, separating professionally from non-professionally executed works. This is a new development. In the past it was important to shake at the foundations of certain professional, restrictive standards. The expansion of the boundaries of art was an entirely characteristic feature of the previous era. Now we have a crisis on our hands because an art that spreads outwards without any limits would be pointless. I remain cautious towards these young people, but I believe that Igor Kapustyansky, for example, is highly talented and is working on certain constructive possibilities.

Claudia Jolles : What changes affecting you have occured in the current political situation?

Ilya Kabakov : Well, of course, the situation has changed, because our entire conscious life has been lived in an atmosphere of extreme fear, fear of a complete and final revenge – for what I do not know. Nowadays we do not anticipate any immediate "punishment", and I am happy about that: happy as I was in school when the maths lesson was cancelled and I could go and play football. A childlike, schoolboyish pleasure that the headmaster was not around to beat me with his cane, even if he might still be waiting around the next corner.

We live at the end of an era, a utopian time of danger and fear. Maybe a genuinely new age is beginning for the next generation . . . Despite all my delight in the wonderful and brilliant future, I stil cannot help feeling anxious about what lies ahead. I would emphasize that our generation is stepping back to make room for another, and that our generation has experienced a period of stagnation. The generation that follows us will consist of new, more powerful, more capable masters of the world, with open spirits and minds, who will of course sniff at our modest, bowed backs and shaking knees. May God grant Gorbachev health!

Erik Bulatov : I would also say that there are grounds for a bit of hope, but there is no telling what the future will bring. The situation is one in which we can live for today. This is something that I never experienced before. I can survive without an additional source of income, that's fantastic, I would be happy if we could live for one or two years like that . . .

Ilya Kabakov : For the first time the onerous burden of defamation has been removed from our art. Only yesterday, in the newspaper, there was something about spies. Let's not talk about it now – but in fact we have spent our entire lives being exposed to the accusation that what we produce is not art, and that we are enemies, scoundrels, almost criminals . . .

Erik Bulatov : I used to be made to feel embarrassed about what I did, I could never rid myself of this complex about being engaged in something illegal. It has been a very important change in our consciousness and our status to be able to feel that we are normal people who are not obliged to conduct their activities in secret. That is something marvellous! Maybe it is just a breathing space. As we say in Russia: "Let's live and then we'll see" – for the time being everything is going well.

Translation from Russian into German and notes by
Madeleine Rollier, from German into English by Martin Scutt.

¹ This idea can be found in its clearest form in Kabakov's album "Primakov who sits in the cupboard" (1972–1975). See also: Ilya Kabakov, "Am Rande" (on the fringe), catalogue published by the Kunsthalle Bern, August/November 1985, p. 28.

² VCHUTEMAS: Moscow Artist's School in the 1920's
³ Akaky Akakyevich Batchmatschkin, the minor official whose hard-earned coat was cruelly stolen from him. From the story "The Coat" by Nicholas Gogol (1809–1852).

PLATES

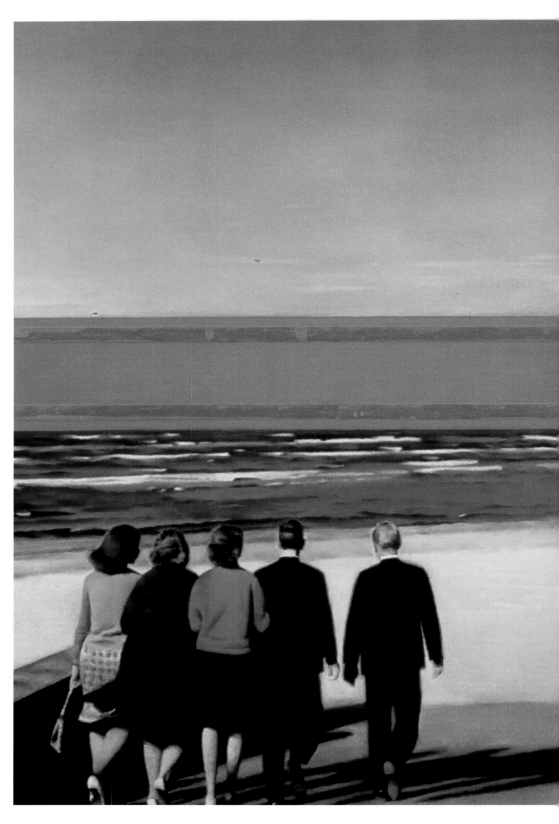

RED HORIZON, 1971–72 140×180 cm / 55×71″

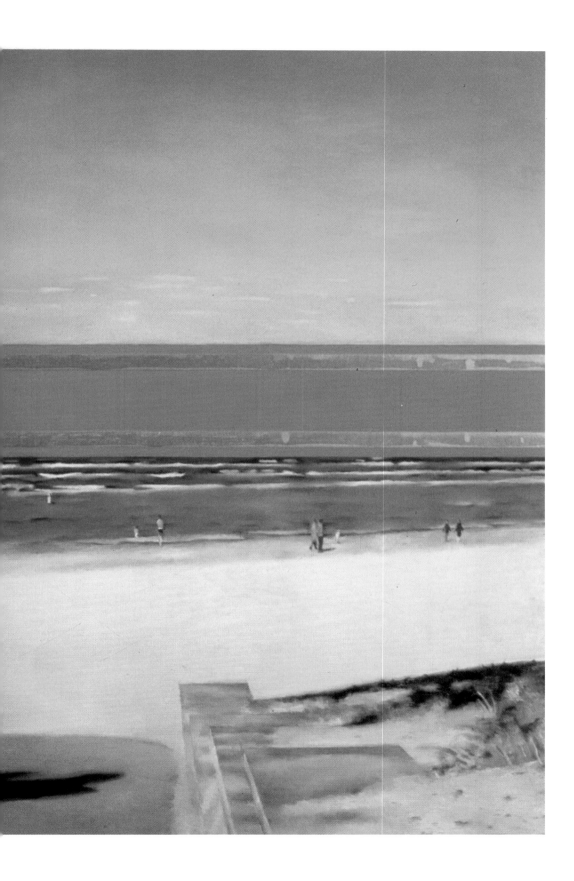

DANGER, 1972–73 110×110 cm / 43×43″

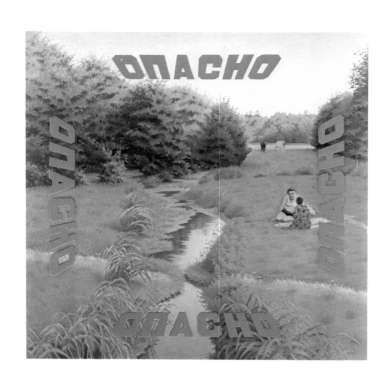

BEWARE, 1973 110×110 cm / 43×43″

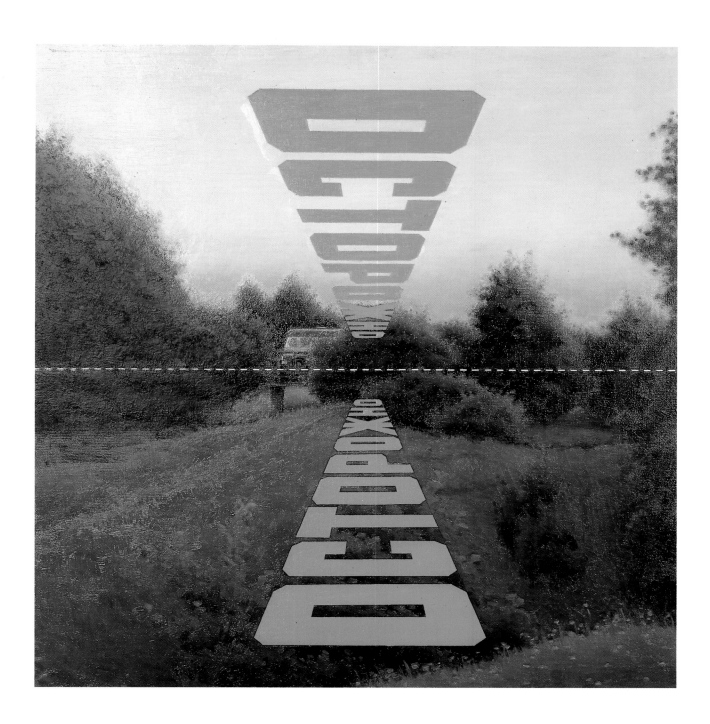

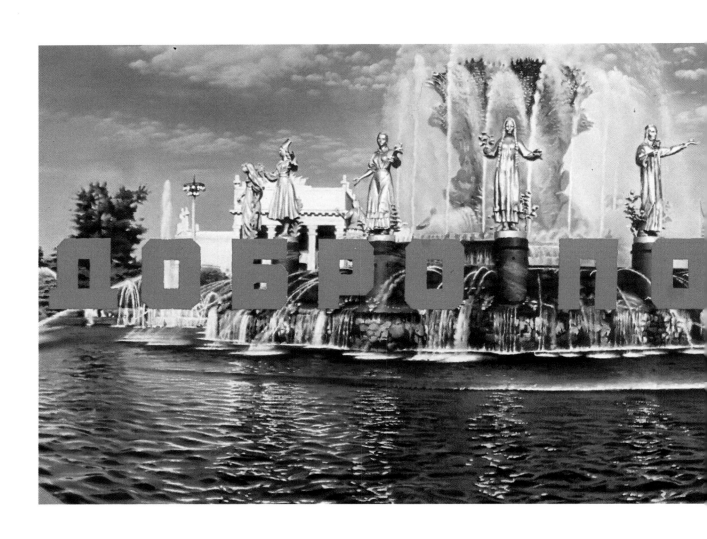

WELCOME, 1973–74 80×230 cm / 31½×90½″

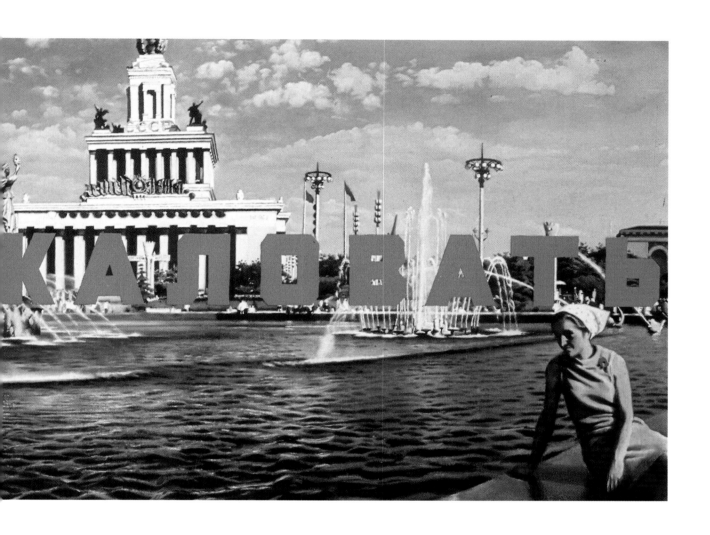

SKIER, 1971–74 180×180 cm / 71×71″

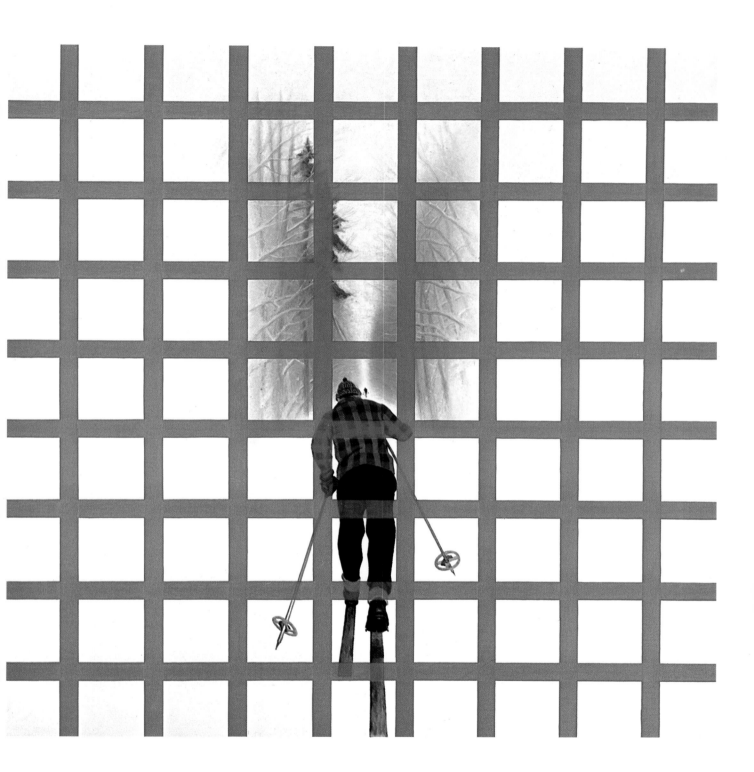

I AM GOING, 1975 230×230 cm / 90½×90½

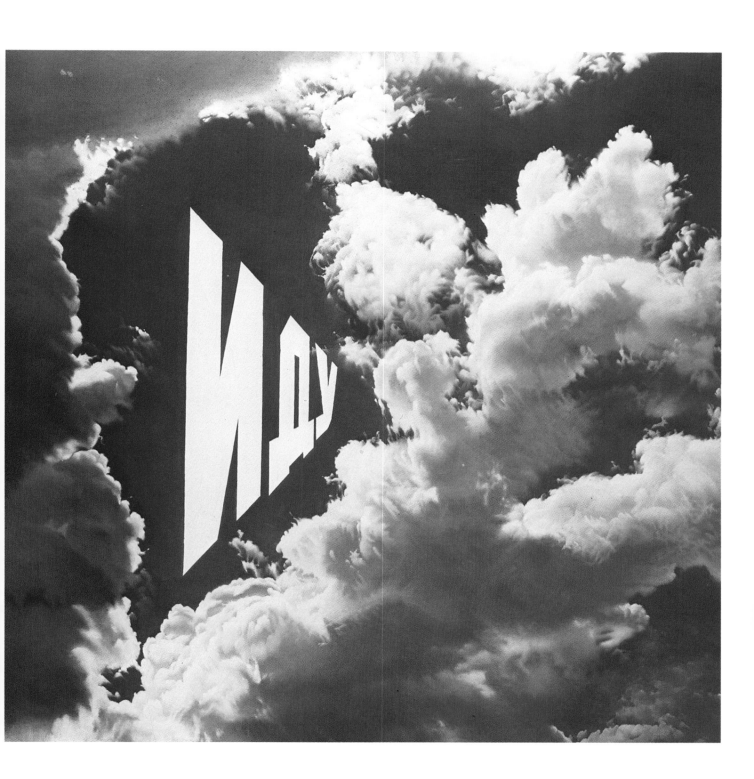

GLORY TO THE CPSU, 1975 230×230 cm / 90½×90½″

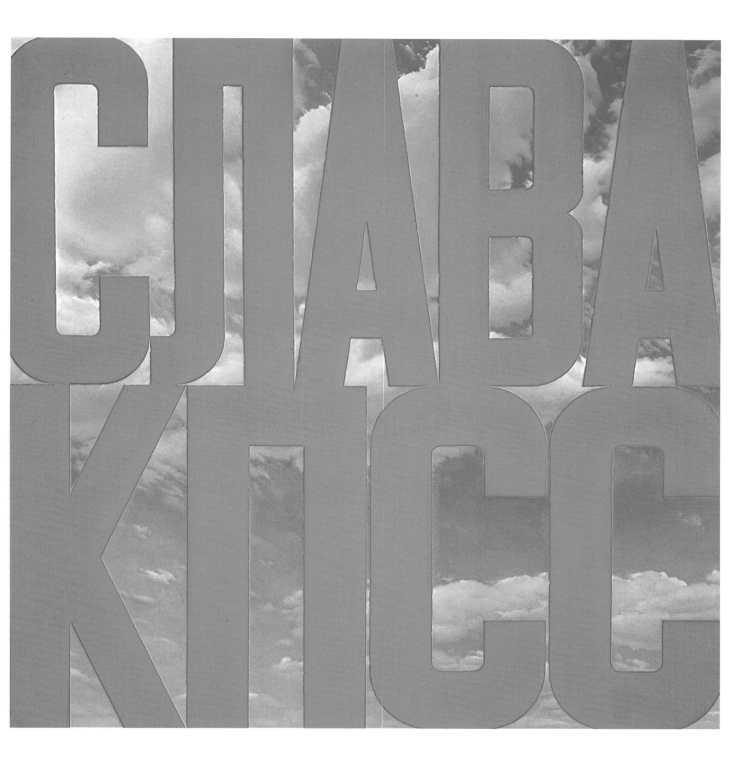

PEOPLE IN THE LANDSCAPE, 1976 140×180 cm / 55×71″

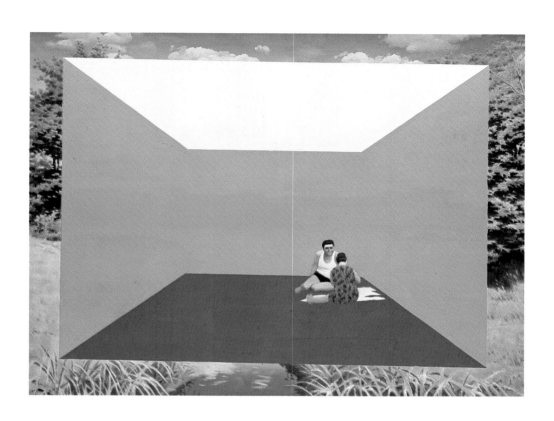

KRASSIKOV STREET, 1976 150×200 cm / 59×79″

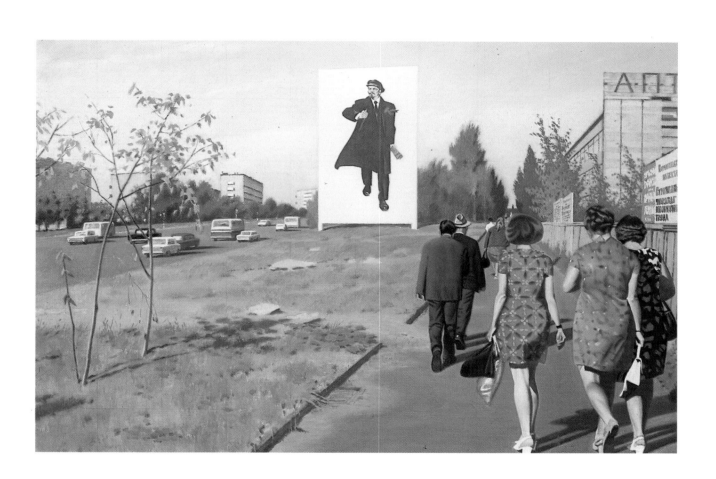

BREZHNEV (SOVIET COSMOS), 1977 270×200 cm / 106×79″

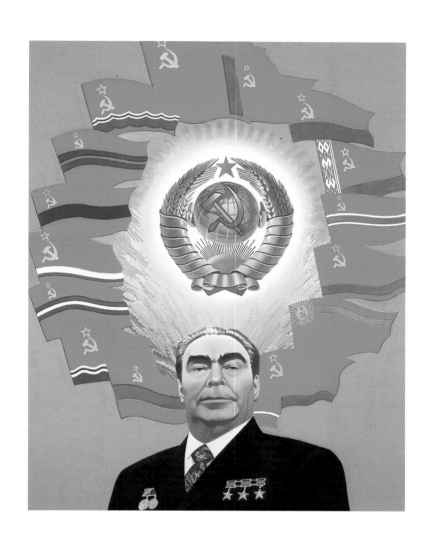

NATASHA, 1978–79 260×200 cm / 102×79″

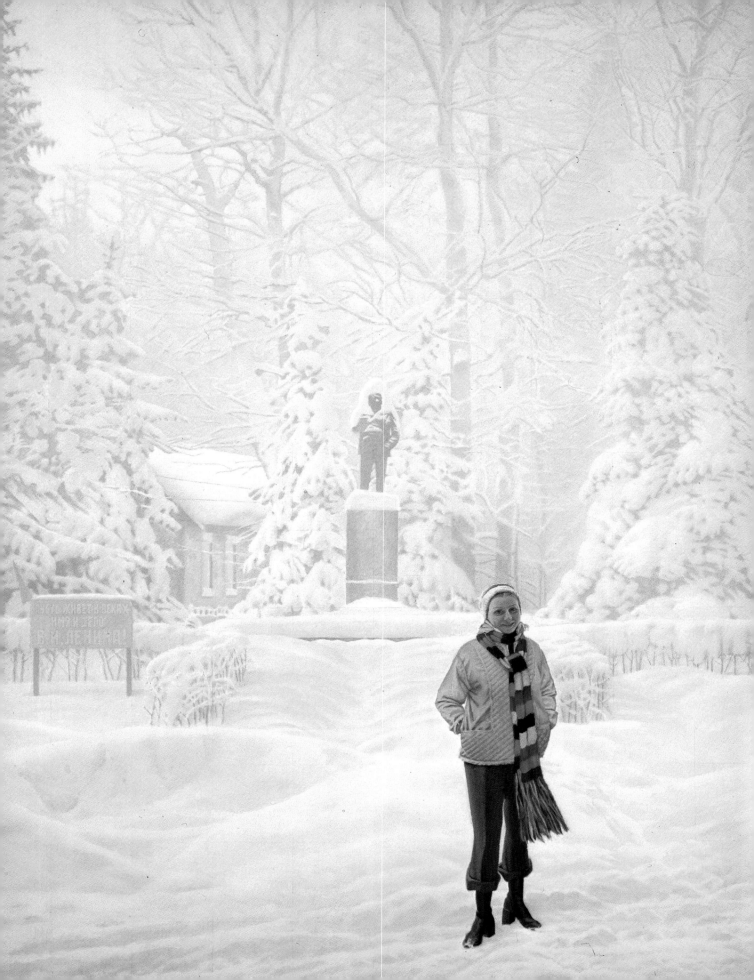

SEVA'S BLUE, 1979 200×200 cm / 79×79″

BREZHNEV IN THE CRIMEA, 1981–85 190×260 cm / 74×102″

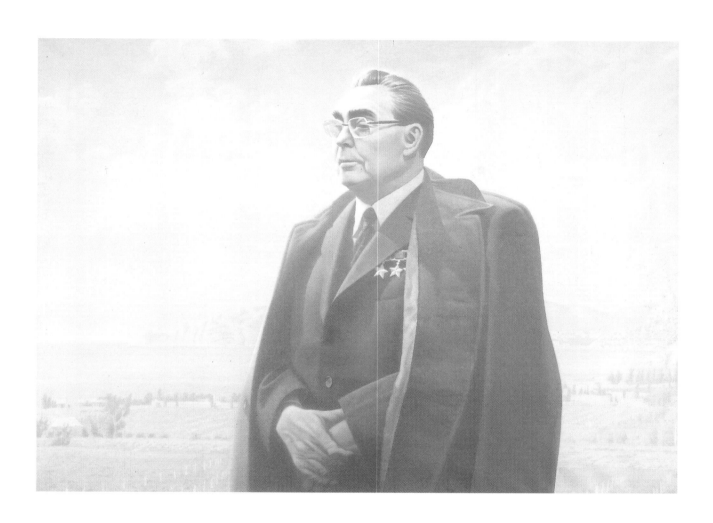

THE POET VSEVOLOD NEKRASSOV, 1981–85 200×200 cm / 79×79″

I LIVE – I SEE, 1982 200×200 cm / 79×79″

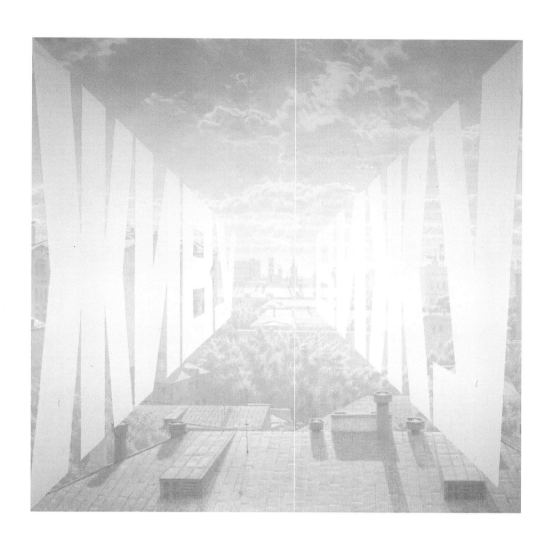

SKY — SEA, 1984 200×200 cm / 79×79″

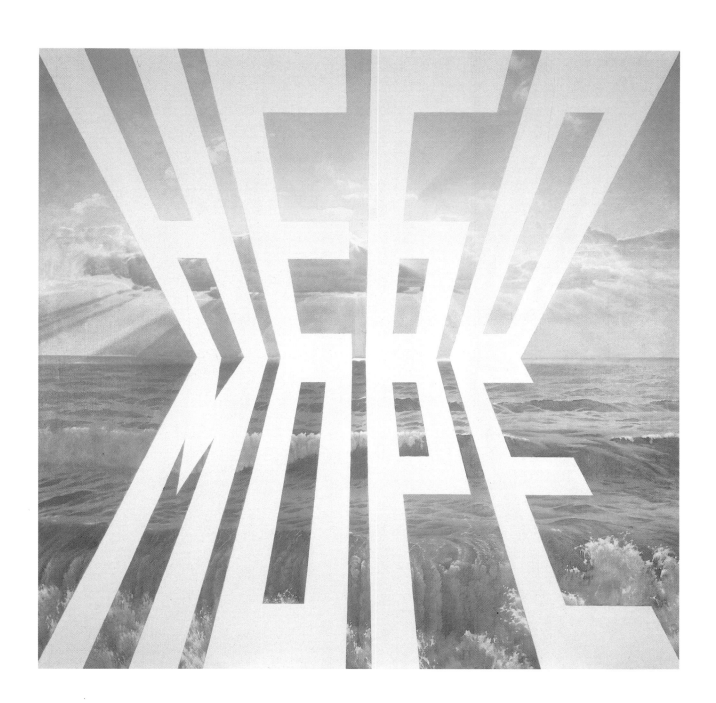

TELEVISION, 1982–85 244×292 cm / 96×115″

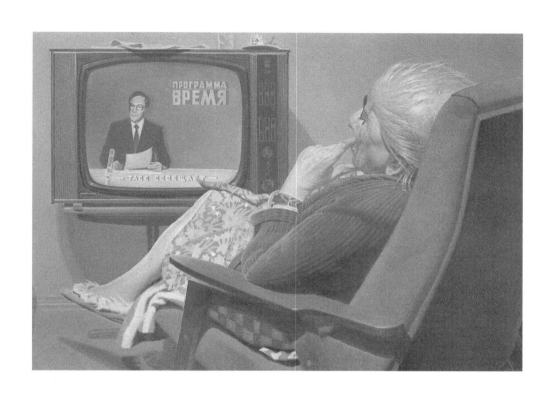

NOT TO BE LEANED ON, 1987 240×170 cm / 94½×67″

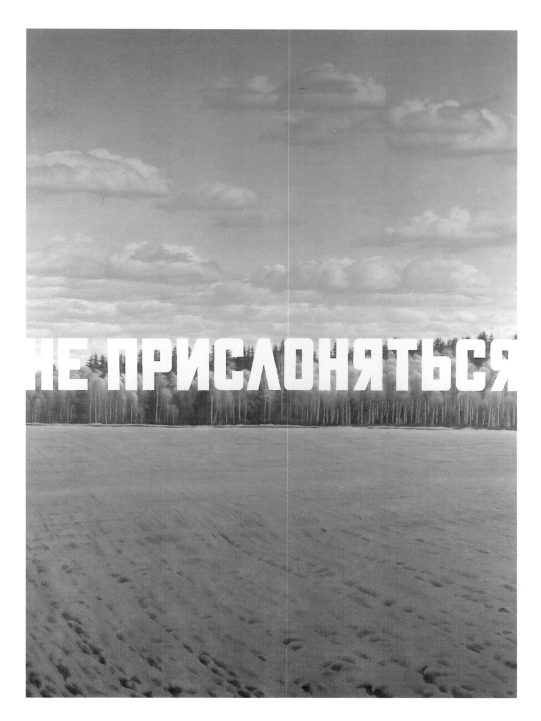

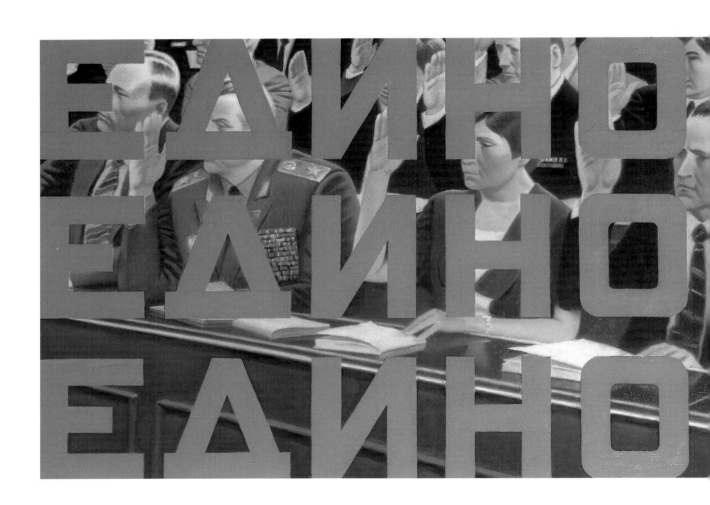

UNANIMOUS, 1987 80×240 cm / 31½×94½″

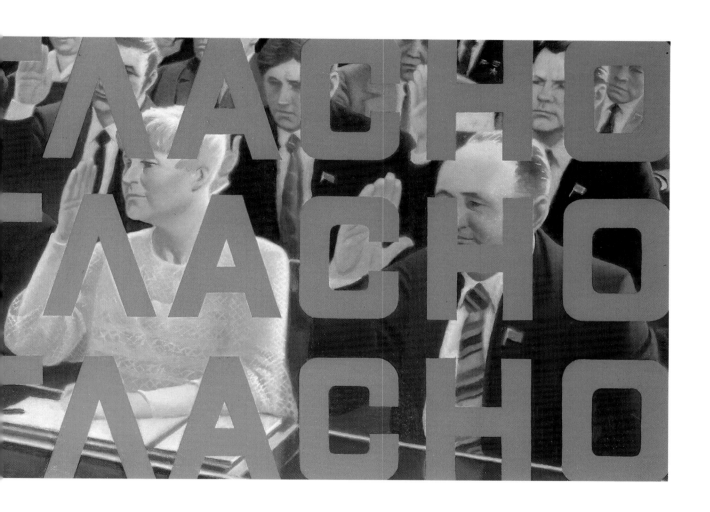

DISPERSING CLOUDS, 1982–87 260×190 cm / 102×75″

REVOLUTION – PERESTROIKA, 1988 200×200 cm / 79×79″

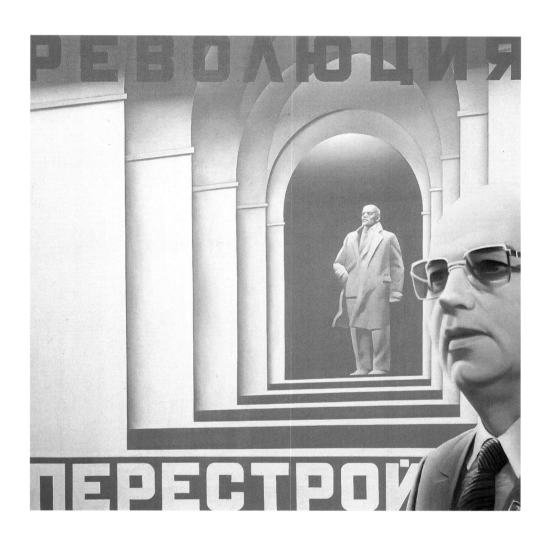

LIST OF EXHIBITED WORKS

THE FESTIVAL, 1967 100×100 cm / 39×39″
private collection, Bern

RED HORIZON, 1971–72 140×180 cm / 55×71″
private collection, Paris

ENTRANCE, 1972 120×120 cm / 47½×47½″
Dina Vierny, Paris

DANGER, 1972–73 110×110 cm / 43×43″
Norton Dodge, Maryland

SELF-PORTRAIT
(THERE IS NO ENTRANCE), 1973
110×110 cm / 43×43″
Dina Vierny, Paris

BEWARE, 1973 110×110 cm / 43×43″
Dina Vierny, Paris

SKIER, 1971–74 180×180 cm / 71×71″
private collection, Bern

ENTRANCE – NO ENTRANCE, 1974–75
180×180 cm / 71×71″
Philippe de Suremain, Paris

I AM GOING, 1975 230×230 cm / 90½×90½″
private collection, Zurich

PEOPLE IN THE LANDSCAPE, 1976
140×180 cm / 55×71″
Norton Dodge, Maryland

KRASSIKOV STREET, 1976
150×200 cm / 59×79″
Norton Dodge, Maryland

GLORY TO THE CPSU, 1975
230×230 cm / 90½×90½″
private collection

BREZHNEV (SOVIET COSMOS), 1977
270×200 cm / 106×79″
private collection, Moscow

NATASHA, 1978–79 260×200 cm / 102×79″
private collection, Bern

SEVA'S BLUE, 1979 200×200 cm / 79×79″
Norton Dodge, Maryland

BREZHNEV IN THE CRIMEA, 1981–85
190×260 cm / 75×102″
private collection

THE POET VSEVOLOD NEKRASSOV,
1981–85
200×200 cm / 79×79″
Norton Dodge, Maryland

I LIVE – I SEE, 1982 200×200 cm / 79×79″
private collection, Bern

SKY – SEA, 1984
200×200 cm / 79×79″
private collection, Geneva

TRADE MARK, 1986
200×200 cm / 79×79″
courtesy of Phyllis Kind, New York

UNANIMOUS, 1987
80×240 cm / 31½×94½″
private collection

NOT TO BE LEANED ON, 1987
240×170 cm / 94½×67″
private collection

REVOLUTION – PERESTROIKA, 1988
200×200 cm / 79×79″
private collection, Moscow

EXHIBITIONS

The School of young Moscow artists,
Moscow, 1956.

International exhibition of young artists,
8th Youth Festival, Moscow, 1957.

Erik Bulatov, Viatcheslav Kalinin,
Institute for Nuclear Physics, Moscow, 1965
(This exhibition was closed after one hour).

Erik Bulatov, Ilya Kabakov,
Bluebird Café, Moscow, 1968.

Russian avant-garde,
Moscow, 1973, Galerie Dina Vierny, Paris, 1973.

La nuova arte sovietica: una prospettiva non
ufficiale,
Venice Biennale, 1977.

Unofficial Soviet art,
ICA, London, 1977.

Photography and Painting,
Centre of Aesthetics, Moscow, 1982.

Photography in Painting,
Museum of the Town of Tartu, Estonia, 1982.

Sots Art,
Semaphore Gallery, New York, 1984.

Erik Bulatov,
Chicago International Center Art Exhibition,
Chicago, 1986.

Group Exhibition,
Exhibition space, Malaïa Grouzinskaïa Street,
Moscow, 1986.

Sots Art,
The New Museum of Contemporary Art, New
York, 1986: Glenbow Museum, Calgary, Canada;
Everson Museum of Art, Syracuse, New York,
1987.

The Artist and his time,
Exhibition space, Kachirskoïe Road, Moscow,
1987.

Direct from Moscow,
Phyllis Kind Gallery, New York, 1987.

Erik Bulatov,
Kunsthalle, Zurich; Portikus, Frankfurt-on-
Main; Kunsthalle, Bonn; De Appel Foundation,
Amsterdam; Kunstverein, Freiburg; Centre
Georges Pompidou, Paris; NGBK, Berlin,
1988.

Aperto 88,
Venice Biennale, 1988.

BIBLIOGRAPHY

Dominique Bozo, J. Nicholson, "Boulatov", Chroniques de l'art vivant, No. 23, Paris, September 1971, p. 13.

Avant-garde russe, Moscou 1973, Paris, Galerie Dina Vierny, 1973 (exhibition catalogue).

"Waschen im Keller", Der Spiegel, No. 15, Hamburg, 7 April 1975, pp. 129–131.

E. Crispoliti, G. Moncada, "La nuova arte sovietica" Venice Biennale, 1977 (catalogue).

M. Hayot, "L'espoir sans espoir, la peinture non officielle russe", L'œil, No. 263, Paris, June 1977, pp. 18–25.

Jiři Chalupecký, "Erik Bulatov. Der Horizont", Propyläen Kunstgeschichte, supplement of No. 2 of Kunst der Gegenwart, Frankfurt-on-Main/Berlin/Vienna 1978, p. 173.

Boris Groys, Interview with Erik Bulatov, A-YA, (Review of non-official Russian art), No. 1, Elancourt, 1979, pp. 26–33.

John E Bowlt, "Das Ziel sind Bilder mit malerischen Werten", DU, No. 6, Zurich, 1981, pp. 32–43.

Boris Groys, "Moderne sowjetische Kunst", DU, No. 6, Zurich, 1981, pp. 23–31.

Vassili Patsioukov, "Erik Bulatov, Edouard Steinberg", A-YA, No. 3, Elancourt, 1981, pp. 14–19.

"Erik Bulatov", Teknitcheskaïa Esteika, No. 6, Moscow, 1982, p. 17.

W. Nagel, "Rot ist nicht mehr die Farbe der Hoffnung", Stern, No. 22, Hamburg, 27 May 1982, pp. 40–60.

Erik Bulatov, "Malevich et l'espace" A-YA, No. 5, Elancourt, 1983, p. 26–31.

"Vsevolod Nekrassov", A-YA, No. 1 (Contemporary Russian Literature), Elancourt, 1985, pp. 36–50.

Frank Barringer, "The 'Unofficial' Artist's Life in Russia", The New York Times, 7 October 1986.

V. Olchevski, "The voyage of 'A-YA' or unofficial art and antisoviet propaganda" Moscow, 20 April 1986, pp. 3–4.

M. Tupitsyn, M. Tucker, J. E. Bowlt, Sots Art, New Museum of Contemporary Art, New York 1986 (exhibition catalogue).

D. C. McGill, "Art Ventures Increase between U.S. and Soviet", The New York Times, 18 May 1987.

S. J. Grossberg, "Speculating on the Margin", Art and Auction, vol. IX, New York, February 1987, pp. 78–84.

Claudia Jolles, "Idu, Ich gehe, I am going" Parkett, No. 12, Zurich, 1987, pp. 19–21.

L. Pachitnov, "Bez biurokratitscheskikh prepol",
Izvestia, 26 March 1987, p. 3.

E. A. Peschler, "Beim Blick in den Spiegel wird vielen noch schlecht",
Das Kunstmagazin, No. 5, Hamburg, May 1987.

Jürg Altweg, "Räume des Lichts Erik Bulatov",
Frankfurter Allgemeine Magazin, Frankfurt, 11 March 1988, pp. 12–20.

Patrick Frey, "Der Maler, der aus Moskau kam",
Wolkenkratzer Art Journal, No. 2, February 1988, pp. 52–55.

L. Kachouk, "Questions and replies without end",
Iskousstvo, Moscow, No. 3, March 1988, pp. 9–15.

Jean-Hubert Martin, "Des Portraits détournés à Moscou et à New York",
Un léger PLUS, Nos. 3–4, Dijon, pp. 31–34.

Fabienne Pascaud, "Bons baisers de Russie",
Marie France, Paris, August 1988, pp. 36–37.

Giacinto Di Petrantonio, "Wind from the East",
Flash Art, Milan, No. 138, January/February 1988, pp. 67–68.

Dieter Ronte, "A l'Est, rien de nouveau",
Art Press, No. 126, Paris, June 1988, pp. 16–17.

Christoph Schenker, "Erik Bulatov",
Noema, No. 17, 1988, pp. 64–71.

Daniel Soutif, "Interview de l'artiste",
Libération, Paris, 13–14 January 1988.

Urs Stahel, "Erik Bulatov. Vielleicht Bloss eine Atempause",
Art: Das Kunstmagazin, Hamburg, No. 1, January 1988, pp. 102–103.

O. Svibova, "A second culture?",
Tvortchestvo, Moscow, No. 7, 1988, 28–31.

O. Svibova, "The artists of Arbat and its surroundings",
Novoïe Vermina, Moscow, No. 142, July 1988.

Erik Bulatov, Zurich, Parkett Verlag, 1988 (exhibition catalogue).

Erik Bulatov, Centre Georges Pompidou, Paris, 1988 (exhibition catalogue).